IMAGES
of America

BUCKHEAD

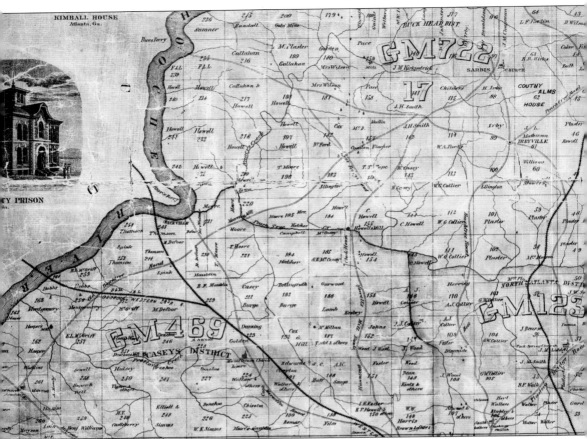

This 1873 land lot map of Buckhead shows the original lots of 202.5 acres. These were distributed in the early 1820s by land lotteries, and tickets cost between $5 and $20. By 1873, many of these lots had changed hands as some people acquired more land. By 1873, men such as Judge Clark Howell; Thomas Moore; Andrew J., Meredith, Merrel, and Wesley G. Collier; Silas Donaldson; and Henry Irby were the large landowners in Buckhead. (Courtesy of the Atlanta History Center.)

On the Cover: The picture shows what the Buckhead Village looked like in 1948. The photograph, taken along Peachtree Road, was shot from Buckhead Avenue looking north. It had the appearance of a typical small-town shopping district of the period, filled with drugstores, hardware stores, filling stations, a grocery store, and movie theater. (Courtesy of the Atlanta History Center.)

IMAGES
of America

BUCKHEAD

Susan Kessler Barnard

ARCADIA
PUBLISHING

Published by Arcadia Publishing
Charleston, South Carolina

Printed in the United States of America

Library of Congress Control Number: 2008943583

For all general information contact Arcadia Publishing at:
Telephone 843-853-2070
Fax 843-853-0044
E-mail sales@arcadiapublishing.com
For customer service and orders:
Toll-Free 1-888-313-2665

Visit us on the Internet at www.arcadiapublishing.com

*To my sister, Nancy, who shared my early experiences
of living in Buckhead, and to my children, Harmon III,
Christopher, and David . . . Buckheadians all.*

CONTENTS

ACKNOWLEDGMENTS

A very special thanks goes to Sam Massell of the Buckhead Coalition, who recommended me to Arcadia Publishing to write this book. His love of the Buckhead community and his support of my book, *Buckhead, A Place for All Time* have never faltered.

My thanks to Michael Rose, Betsy Rix and the library staff at the Atlanta History Center Library and Archives, Sandra Berman and Ruth Einstein at the Breman Museum Library, Steven W. Engerrand and Gail DeLoach at Georgia Archives, and the Atlanta Public Schools, who supplied photographs from their collections.

Descendents of some of Buckhead's 19th- and early-20th-century pioneer families went the extra mile. From the Irby, Hicks, Donaldson, Rolader, Ottley, Allen, Spalding, and Haverty families came pictures from Eleanor Eidson Foster, Margaret Townsend, Gloria Donaldson Wells, Dan Vickers, Weyman Brown, John K. Ottley Jr., Beaumont Allen, Van Schroder Waddy, and Elizabeth Haverty Smith.

There are many others who provided pictures or helped me find materials for this book. Thanks to Dr. Henry Hope, Laura Smith Spearman, Dodie Black Stockton, Edyth K. Shadburn, Eleanor Wright Linn, Alva and Mildred Lines, and Fran Crossett Rosenthal. Then there are William Bullard, Ruth Carter, Sarah Cunningham Carpenter, Jean Davis, Joan Torgeson Doyle, William Haley, Stokes Hill, Deede Levy Jessup, Susan Simmons Johnson, Carolyn Mitchell, Tennent Neville, Helen Robinson Peppiatt, Nancy Powers, Dr. Keith Quarterman, David Smith, Marjorie Stow, Matthew Jeffres, Rodney White, Shunya Thompson of Wolf Camera and Image, and the Peachtree Battle Barber Shop owners.

I much appreciate the photographs from Rev. J. R. McAliley of Center Congregational Church, Anne Parr of Northside United Methodist Church, Jerry Poole at Northside Drive Baptist Church, Steven F. Unti and Jane Ross at Paces Ferry United Methodist Church, Luther Bootle at Second Ponce de Leon Baptist Church, and Benita Johnson at St. Anne's Episcopal Church. Patti A. Hughes of the Lovett School, Linda Smith at Pace Academy, Cathy Kelly at the Westminster Schools Archives, and Diane Erdeljac at Piedmont Hospital (Piedmont Healthcare) also provided pictures.

A second thanks goes to the people who shared pictures with me for *Buckhead, A Place for All Time* that I am using in this book: Tate Anderson, William Brand Jr., Dr. F. Phinizy Calhoun Jr., Sara H. Jordan, Peachtree Road United Methodist Church, Elizabeth Few, John W. Grant III, Ellie Patterson Laudermilk, Sharon Matthews, Helen Bagley McDuffie, Nancy Kamper Miller, Thomas Murray, Carol Meadows Murphy, Maybelle Tatum Osburn, Margaret Chapman, and Bruce Woodruff.

INTRODUCTION

Today's Buckhead is made up of single-family homes, high- and low-rise condos, apartments, houses of worship, towering office buildings, multiple shopping centers, museums, galleries, hospitals, and parks.

This thriving community, only 4 miles from downtown Atlanta, had very humble beginnings. The first residents were the Paleo-Indians who lived and hunted in the virgin forest along the Chattahoochee River approximately 6,000 to 8,000 years ago. By the mid-1700s, the Muscogee (Creek) Indians inhabited the area in the village of Standing Peach Tree. During the War of 1812 and the Creek Indian War of 1813–1814, they witnessed the disruption of their village life. In the spring of 1814, federal troops led by Lt. George Rockingham Gilmer (a future governor) came into the area and built Fort Peachtree. On a nearby creek, James McConnell Montgomery and his men instituted a boatbuilding project.

The Creek Indians were forced to cede a major portion of their land to the State of Georgia in the 1821 Treaty of Indian Springs. Part of this land later became Atlanta and Buckhead.

When the Native Americans left, white settlers arrived and developed a new community. They built houses, established ferries across the Chattahoochee River, and operated gristmills, sawmills, farms, and a tavern. In 1838, when someone shot a buck and placed it either over Henry Irby's doorway or on a pole in his yard, the area became known as Buck's Head. Thus a community's name was born.

In 1864, Buckhead stood in the path of the Civil War, as Union troops skirmished throughout her forests and bivouacked before fighting in the Battle of Peachtree Creek (in Buckhead) and the Battle of Atlanta.

Following the war, Buckhead's population increased, and pottery factories were added to the commerce of the area. Free schools were established in the 1870s.

Buckhead was home to several black neighborhoods, where residents built homes, churches, and stores. Some had the support of their former masters, for whom they continued to work.

Around the beginning of the 20th century, some of Atlanta's wealthy citizens bought large tracts of land in Buckhead, developed small farms, and built cottages. When the streetcar reached the community in 1907, Buckhead became their permanent residency, and their friends followed.

The Buckhead community felt the effects of World War I, the Ku Klux Klan, the Great Depression, and World War II. The annexation of Buckhead into the city of Atlanta in 1952 changed the community forever. No longer would it be a quiet, sleepy, rural community. Fortunately, the street names continue to remind us of those early settlers.

One

THE LAND BEFORE BUCK'S HEAD AND STANDING PEACH TREE
THE ARCHAIC PERIOD–1821

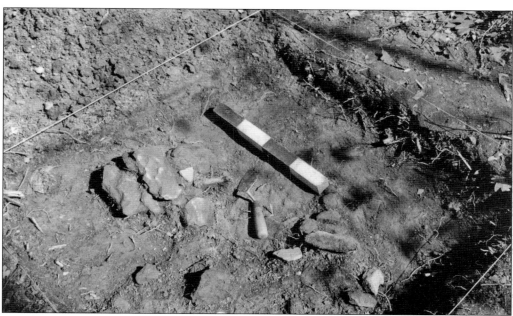

In 1971, an archaeological survey was done of the Standing Peachtree area along the Chattahoochee River at Peachtree Creek. It dated its finds to a Native American inhabitancy in the Mississippian Period (500 AD–1200). In 1993 and 1994, Glenn Armstrong, David Chase, David Smith, and the author, all members of the Greater Atlanta Archaeological Society, launched a dig in an attempt find remains of early American Indian cultures. A hearth of granite was unearthed, and pieces of plain, sand-tempered potsherds and quartz flakes were found nearby. These were dated to the Archaic Period (8000 BC–6000 BC). Also found was a small projectile point that suggested a Woodland Period (1000 BC–500 AD) inhabitation. It is reasonable to say that the earliest residents of Buckhead were the Paleo-Indians of the Archaic Period. (Courtesy of author.)

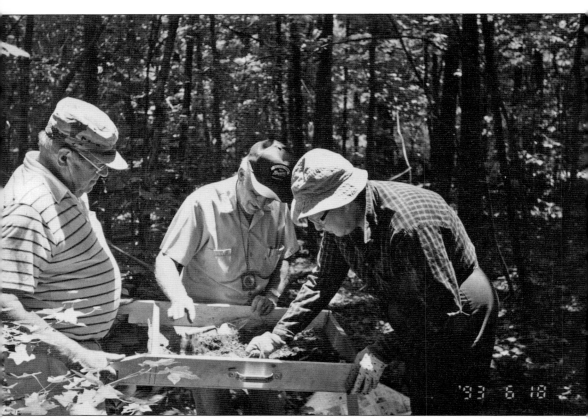

From left to right, Glenn Armstrong, David Chase, and the author sift through dirt during the archaeological dig at Standing Peachtree. (Courtesy of David Smith.)

Because of hostilities between the Muscogee (Creek) Indians and Georgia settlers during the War of 1812 and the Creek Indian War of 1813–1814, forts were built along Georgia's frontier. In March 1814, Lt. George Rockingham Gilmer and his men arrived at Standing Peach Tree and built Fort Peachtree. James McConnell Montgomery's boatmen built boats for a river supply line to the Georgia Militia 150 miles south at Fort Mitchell. (Courtesy of author.)

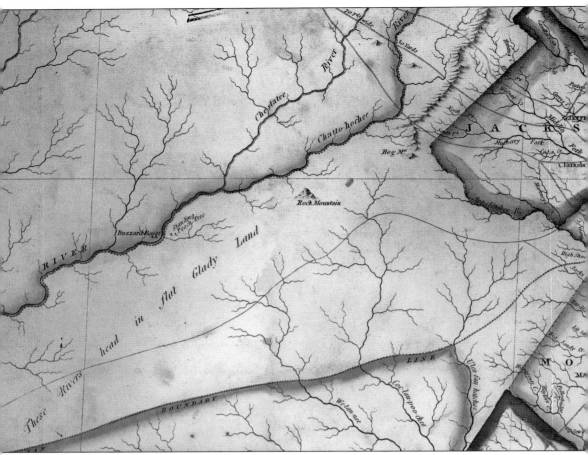

This 1818 map shows what later became Buckhead and other communities. Note the western boundary at the Chattahoochee River and Standing Peach Tree. To the northeast, and misplaced, is Rock Mountain, known today as Stone Mountain. Farther northeast is Hog Mountain, the site of Fort Daniel. The road from Fort Daniel to Standing Peach Tree was called Peach Tree Road and is the oldest road in Atlanta. (Courtesy of the Atlanta History Center.)

Two

THE BUCK STOPPED HERE
1821–1865

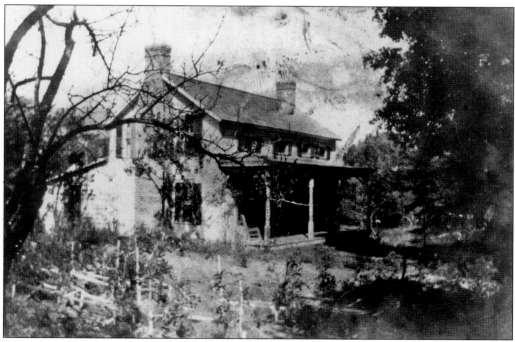

After the Muscogee (Creek) Indians ceded this portion of their land in 1821, James McConnell Montgomery returned to Standing Peach Tree. He built this plantation-style home for his wife, Nancy, and their 13 children. An entrepreneur, he was a ferryman, a census taker, and a land assessor. He served as DeKalb County clerk of the court of ordinary, a Poor School commissioner, and a Standing Peach Tree Post Office postmaster. (Courtesy of Troy Anderson.)

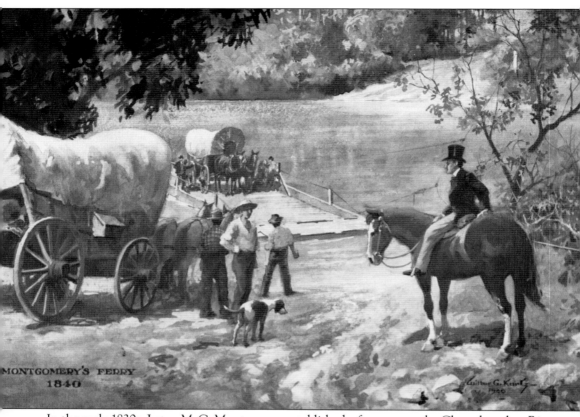

MONTGOMERY'S FERRY
1840

In the early 1830s, James McC. Montgomery established a ferry across the Chattahoochee River that served for 40 years as a major river crossing transporting travelers and livestock. It is depicted here in a Wilbur Kurtz painting. Ferries were public utilities regulated by the Georgia legislature. Ferrymen charged 6¢ per person, 10¢ to 12¢ for a man and horse, and 2¢ to 4¢ per farm animal. (Courtesy of the Atlanta History Center.)

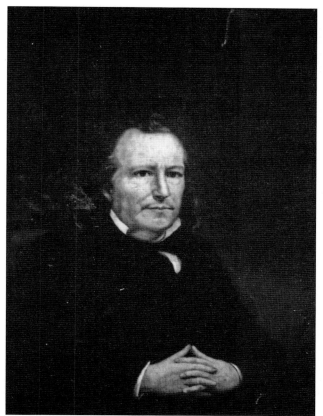

Henry Irby, born in South Carolina in 1807, was the son of a harness maker. In 1833, he married Sardis Walraven, and they had 10 children. In 1838, Irby bought 202.5 acres of Land Lot 99 around the present Peachtree, Roswell, and West Paces Ferry Roads from Daniel Johnson for $650. There he built a home and a tavern. The tavern is depicted here in a Wilbur Kurtz painting. A buck was shot, and its head was mounted either over the tavern door or on a yard post. Farmers traveling through the area on their way to Atlanta markets and planning to meet up with neighbors would say, "See ya at th' Buck's Head," and Buck's Head/Buckhead was born. (Above courtesy of Carol M. [Mrs. Mile] Murphy and Sara H. [Mrs. Binion] Jordan; below courtesy of the Atlanta History Center.)

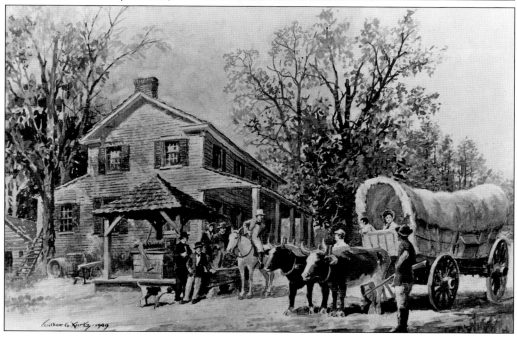

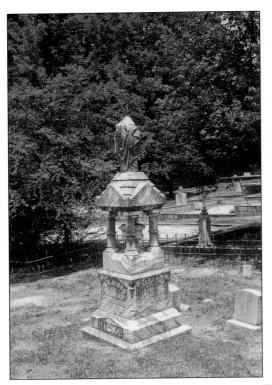

Settlers began moving into the Buckhead area, and soon a cemetery became necessary. Land on today's Powers Ferry Road was found, and Shady Oaks Cemetery was established. The earliest recorded interment is that of Charlie Jett, who died in 1839. Today the cemetery is located at Sardis Methodist Church and is the resting place of many of Buckhead's pioneers. (Courtesy of author.)

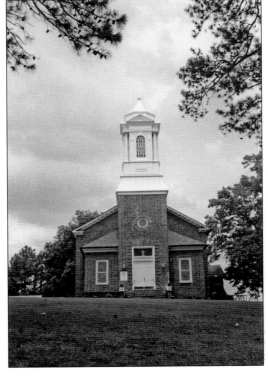

Sardis Methodist Church, the oldest church in Buckhead, got its start in a log chapel around 1825 and was served by circuit-riding preachers. After the Civil War, the cabin was moved onto Silas Donaldson's property and was used to store wheat. In its place, the members of the church built a two-story frame building. After it was damaged in 1875 by a cyclone, it was rebuilt. (Courtesy of author.)

Clark Howell retired from the Atlanta City Council in 1852 and purchased about 4,000 acres of land around today's intersection of Howell Mill and Collier Roads. He built a grist and sawmill on Peachtree Creek, shown here in Wilbur Kurtz's painting, where it passes underneath today's Howell Mill Road near Peachtree Battle Avenue. In 1861, he became a member of the first Inferior Court of Fulton County and went on the bench. He later served in the Georgia legislature and was a Fulton County commissioner. As Union troops approached the area in July 1864, the family sought refuge farther south. After the Civil War, they returned to find their house and mill in ruins. Howell's son, Evan, took over operation of the rebuilt mill and supplied lumber to rebuild Atlanta. He made enough money to eventually buy the *Atlanta Constitution* newspaper. (Both courtesy of the Atlanta History Center.)

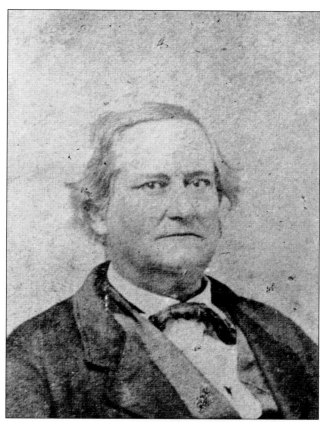

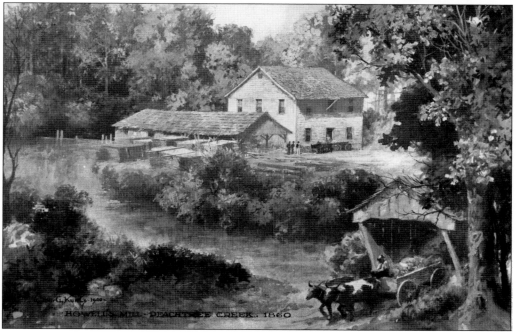

HOWELL'S MILL. PEACHTREE CREEK. 1860

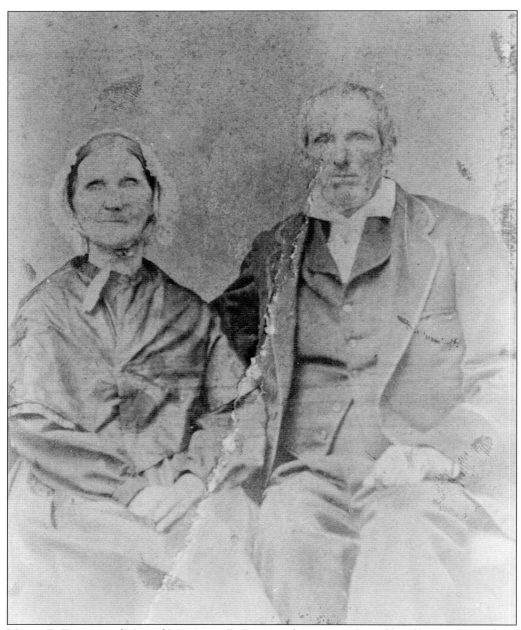

Martin DeFoor, son of Mr. and Mrs. James DeFoor, was born in 1805 in Abbeville, South Carolina. He married Susan Tabor, daughter of the Reverend John and Elizabeth Tabor. In 1853, DeFoor and James Moore moved their families to DeKalb County. The families merged when Moore's son, Thomas, married DeFoor's daughter, Elizabeth. In 1853, DeFoor and Thomas Moore bought 1,000 acres of Standing Peach Tree land from James McC. Montgomery's heirs. The DeFoors moved into Montgomery's home, and Martin DeFoor took over the operation of Montgomery's Ferry, changing the name to DeFoor's Ferry. On the morning of July 25, 1879, Martin and Susan were found brutally murdered in their bed. Though suspects were arrested, the crime was never solved. (Courtesy of the Atlanta History Center.)

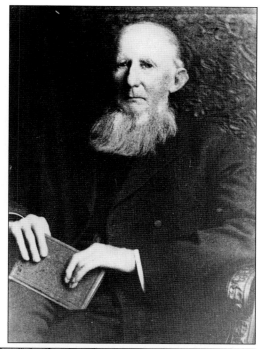

Thomas Moore's parents, James and Ann, immigrated to America in 1825 and settled in Abbeville, South Carolina. Thomas and his wife, Elizabeth DeFoor, settled near Standing Peach Tree, where they built a home and a gristmill on Peachtree Creek. They had one son, James. Hotheads opposed to his stand against secession torched the mill in 1860. It was rebuilt, but Federal troops burned it down during the Civil War. After the war, the new mill continued to operate until 1901. In 1914, while he was riding in his horse-drawn buggy, an interurban car frightened Moore's horse. He was thrown from his buggy and died. In 1960, wanting a watercolor of the mill, his great-grandson sent a 1900 picture of the mill to Wilbur Kurtz; this is Kurtz's sketch. (Both courtesy of the Atlanta History Center.)

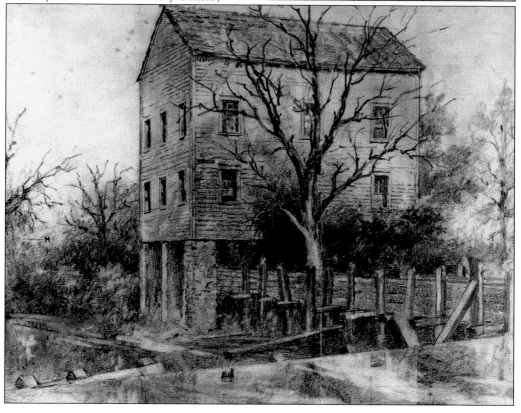

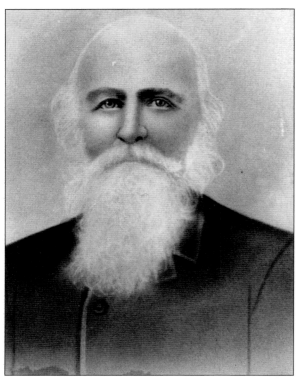

Silas Harper Donaldson (1825–1892) came to Buckhead from Ireland probably in the 1850s and married Mary Anne Collier (1829–1885). Mary Anne was the 14th child of Meredith Collier and his wife, Elizabeth (Gray), who came to the Buckhead area in 1823 and purchased land around Peachtree Creek. Their house was on today's Peachtree Road at Collier Road. The Donaldsons lived at the corner of Roswell and Tuxedo Roads and reared a large family. Donaldson donated land on Powers Ferry Road for Sardis Methodist Church and helped build the two-story framed building. When the Donaldsons died, they were interred in the mausoleum in front of Sardis Cemetery. They were later moved to West View Cemetery. (Both courtesy of Margaret Donaldson Townsend.)

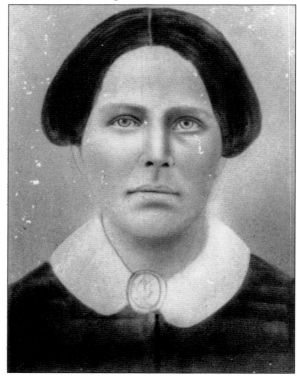

Rial Bailey Hicks was postmaster of the Buck's Head Post Office (1853–1861) and later a schoolmaster. He married Henry Irby's daughter, Sarah Jane, and they had 10 children. During the Civil War, Hicks served as a first lieutenant in a regiment of Georgia Reserves. Afterwards, he managed Irby's store. The Hickses are buried at Sardis Methodist Church Cemetery. (Courtesy of Sara Hammett Jordan.)

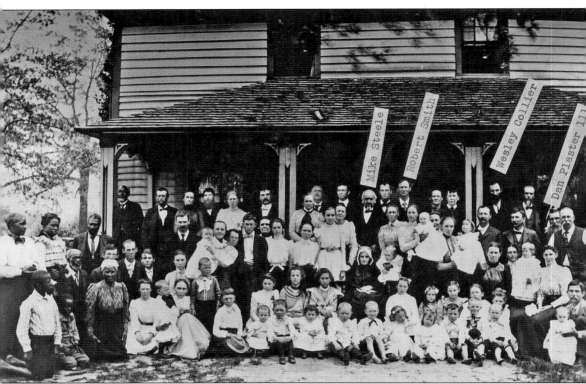

Benjamin Plaster, born in North Carolina in 1780, married Sarah Sewell; they had six children. They moved to Franklin County, Georgia, and he served in the Georgia Militia during the War of 1812. In the 1830s, Plaster bought 1,316 acres in Buckhead around today's Piedmont Road and Lindbergh Drive. This 1880 photograph at Plaster's home includes members of the Plaster, Smith, Collier, and Steele families and some of Plaster's former slaves. (Courtesy of the Atlanta History Center.)

One-year-old Mary Magdalena and her 12-year-old brother, William Joseph Rolader, emigrated in 1828 from Prussia to Charleston, South Carolina. It is believed that their parents died during the sea voyage. The orphans traveled to North Georgia, where they lived in foster homes until a Hall County family took them in. Mary married Joshiah William DeHay and moved to Texas, where she died in 1883. (Courtesy of Dan Vickers.)

In 1834, William Joseph Rolader (1816–1893) joined the Methodist Episcopal Church South and became a circuit-riding preacher. He married Ann Gunter (1820–1905), shown here in later years, and they had eight children. By 1858, they were living in Buckhead. After a few years in Alabama, they returned to Buckhead in the early 1860s, and William preached at Pleasant Hill and at Sardis Methodist Churches. (Courtesy of Dan Vickers.)

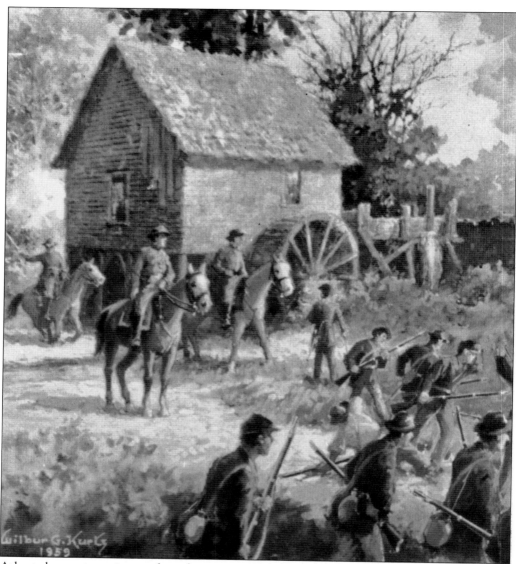

Atlanta became a major supply and transportation center for the Confederacy during the Civil War. In the spring of 1864, Gen. Ulysses S. Grant, commander of the Northern armies, issued an order to take the war to enemy country and destroy the Confederate army and its assets. On July 16, Union soldiers crossed the Chattahoochee River. On the 20th, they attacked Confederate forces near Peachtree Creek in the area of the present Piedmont Hospital and around Northside Drive. A two-hour battle took place around Andrew J. Collier's mill on the Tanyard Branch, as seen here in Wilbur Kurtz's painting. When the Battle of Peachtree Creek ended, the Confederates had been badly beaten. Federal troops moved south, where the Battle of Atlanta was waged on July 22. The mayor surrendered the city on September 2. (Courtesy of the Atlanta History Center.)

Three

TH' YANKEES ARE GONE, DIG UP TH' SILVA
1865–1899

In the mid-1800s, Dr. James H. "Whispering" Smith (1804–1872) came to the Buckhead community and bought 405 acres of land along Peachtree Road, now West Paces Ferry Road. In 1870, he established Harmony Grove Cemetery at the present corner of Chatham Road. When he died, he was buried in his cemetery (shown above). Martha W. Smith inherited her husband's estate, and in 1903, she sold much of her land to James L. Dickey Sr. for $6,000, or $15 per acre. In 1918, Buckhead merchant and drugstore owner John N. Sims bought the cemetery. He died the following year, and an obelisk marks his burial site. His son, Walter (mayor of Atlanta from 1922 to 1926), inherited the cemetery, and when he died in 1953, he was also buried there. At a later date, the Harmony Grove Baptist Church was built next to the cemetery. (Courtesy of author.)

Shown here are other graves in the Harmony Grove Cemetery. (Courtesy of author.)

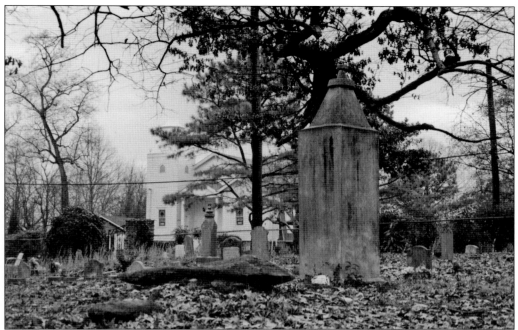

Shortly before his death, Dr. James H. "Whispering" Smith deeded 3 acres of land to his former slaves along present-day Arden Road for a place to worship and for a cemetery. Across the street from the present cemetery, worshipers at the New Hope Campground met under a brush arbor made of four poles covered with tree branches. The Reverend Roland Wishum is credited as the driving force in bringing the first group of worshippers together. Later they joined the African Methodist Episcopal Church movement, founded in 1793 by former slave Richard Allen of Philadelphia. The Reverend Joseph Woods became the first pastor of New Hope Church. In 1887, the congregation bought additional land across the street for a new cemetery. In the late 1890s, the congregation built a wooden tabernacle, shown below. (Above courtesy of author; below courtesy of Elizabeth [Mrs. Moses] Few.)

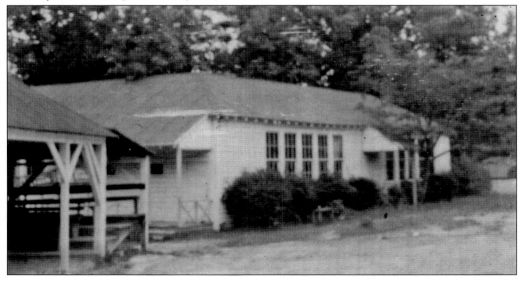

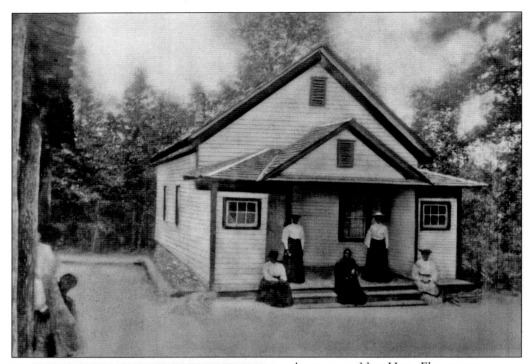

A one-room New Hope Elementary School was built in the churchyard in 1910 and became an important element in Buckhead's black community; a second room was later added. There was no running water inside the school, and there were privies located outside the building. After graduation, students went downtown to Washington High School, often driven there by the chauffeurs of the well-to-do in their employers' cars. (Courtesy of Elizabeth Few.)

The New Hope tabernacle was destroyed by fire in 1927, and the congregation replaced it with a new sanctuary in 1936. To pay for the construction, church members took out loans on their properties, and many in the white community donated funds. The Smithsonian Institute honored the church in 1991. (Courtesy of author.)

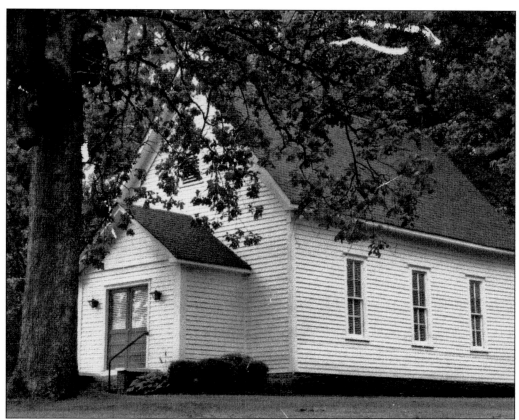

Pleasant Hill Church was established on September 29, 1877, when William Brown deeded an acre of land on Paces Ferry Road at the intersection of Mount Paran Road to himself and James Baxter as trustees of the Methodist Church South. A cemetery was established and a small white frame sanctuary was built. The congregation often shared a preacher with other churches, alternating Sundays; one of these ministers was the Reverend William Joseph Rolader. At one time, the Pleasant Hill School, a private school, was located in the church building. One of the teachers was Ida Williams, for whom the Buckhead library would later be named. The church was renamed Paces Ferry United Methodist Church in 1957. (Above courtesy of Paces Ferry United Methodist Church; below courtesy of author.)

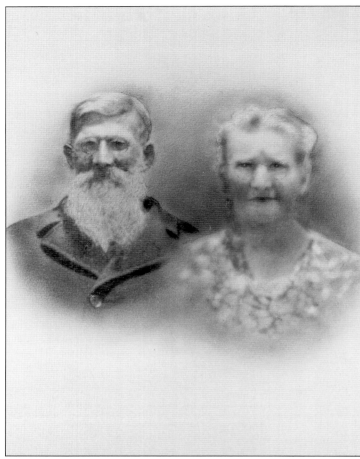

William Washington "W. W." Rolader (1856–1922) was the sixth child of Rev. William Joseph and Ann (Gunter) Rolader. He married Arrie Cofield, daughter of potter Thomas B. Cofield. In 1886, W. W. bought 50 acres of land on Moores Mill Road from Mrs. Clark (Mary) Howell Sr. for $800. He built a small log cabin that was chinked with potter's clay; he enlarged the cabin over the years to make room for his growing family. Rolader was a farmer and a potter; his Rolader's Pottery factory was located east of the cabin. Today the original cabin is located in the museum at the Atlanta History Center. (Above courtesy of Dan Vickers; below courtesy of Maybelle Tatum Osburn.)

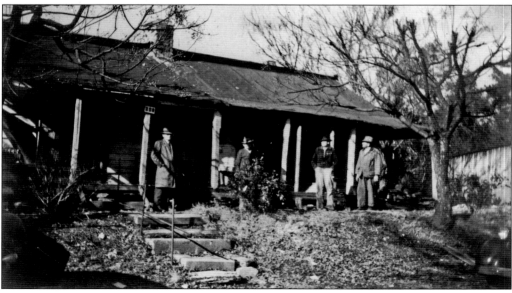

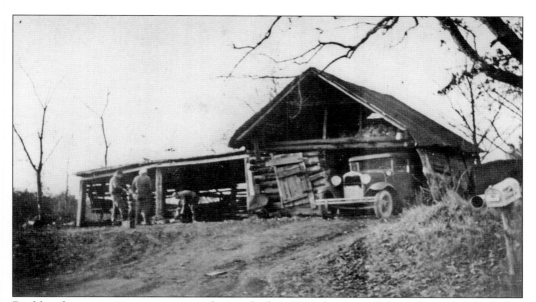

Buckhead was a major pottery town during the late 1800s because of the rich supply of red clay. The family-owned and -operated potteries of Rolader, Bowling Brown, and Thomas B. Cofield were located along creeks, which provided the clay. Rolader made jugs, churns, flowerpots, whiskey jugs, chimney flu liners, and milk containers. Later Ulysses Adolphus "Dolphus" Brown leased Rolader's factory and operated Brown's Pottery until 1933. (Courtesy of Maybelle Tatum Osburn.)

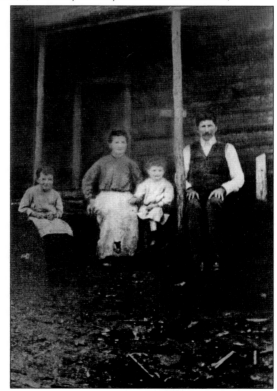

Rev. Lorenzo Dow Rolader (1854–1937) was the son of Rev. William Joseph Rolader. He and his wife, Mary Elizabeth (Haley), lived in a one-room log house in Cox's Crossroads in the Howell Mill and Moores Mill Roads area. Along with being the minister of Center Congregational Church, he operated a grocery store on the corner of Northside Drive and Moores Mill Road and was pastor of the Fulton County Almshouse. (Courtesy of Dan Vickers.)

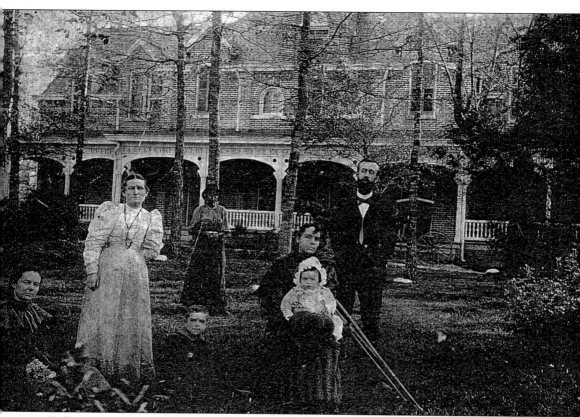

Robert Lawson Hope, born in 1859 to Martha and Lawson Henderson Hope, became a doctor in the science of homeopathic, manipulative, and herbal medicine. He married Sarah Della Plaster. Following graduation, he became director and resident physician of the Fulton County Almshouse (1881–1909). Shown in the picture are the Hopes, their children, several almshouse residents, and a servant at the first location on Piedmont Road near Peachtree Road. (Courtesy of Dr. Henry Hope.)

On September 19, 1899, the trustees of the Piney Grove Church, a place of worship for black members of the community, bought land on the present Canterbury Road between Lenox Square and Lindbergh Plaza from John Mayson for $50. The Piney Grove congregation worshiped under a brush arbor near an old slave cemetery on their acre of land until they later built a permanent sanctuary. (Courtesy of author.)

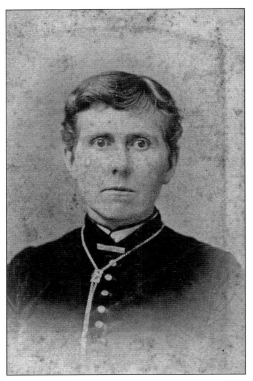

Jane Donaldson (1849–1931) was the eldest daughter and second child of Silas and Mary Ann Donaldson's 11 children. She was teaching elementary school in Atlanta when her parents told her to return home and help run the house and assist with her younger siblings. Afterwards, she opened a "jot-'em-down" country store, a business where the proprietor would take down the orders on a piece of paper, add up the items, then present the bill. Her store was known as the Little Old Store Beside the Road on Roswell Road at the present corner of Blackland Road. She sold food, clothing, and hardware. Her brother Reuben Aaron Donaldson (1864–1925), shown here, was married to Sarah "Sallie" Rebecca Hawk of Morgan County, Georgia. (Both courtesy of Gloria Donaldson Wells.)

Otella Mae Hicks (1880–1973), the youngest of nine children born to Rial Bailey and Sarah Jane (Irby) Hicks, was Henry Irby's granddaughter. In 1901, she married James Sylvanus Donaldson, and they had four daughters. When her father died, she and her family moved into her mother's Peachtree Road home (at present-day Rumson Road) to care for her. Mae died at 93 and is buried in Sardis Methodist Church cemetery. (Courtesy of Gloria Donaldson Wells.)

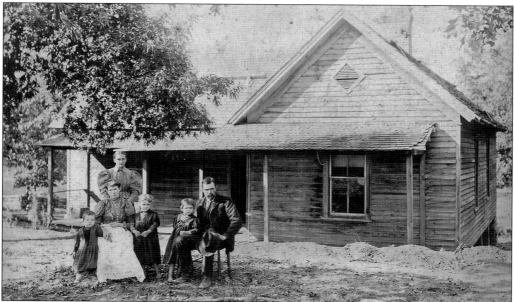

Dr. George Obadiah Chapman practiced medicine in Buckhead for 50 years, ministering to white and black citizens of the community. When he and Cora Donaldson married, her father, Silas Donaldson, gave the couple land on Roswell Road near present-day Wieuca Road. They had five children. Shown in this 1894 picture are, from left to right, Russell Lewis; Cora (seated); Cora's mother-in-law, Laura Beecher Chapman (standing); daughter Laura Anie; daughter Clara Jane; and Dr. Chapman. (Courtesy of Margaret Townsend.)

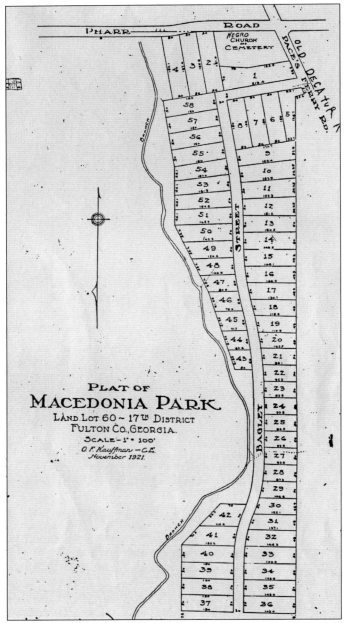

In 1874, John S. Owens bought former Irby land on today's Pharr Road for the Macadonia Park subdivision for black citizens of Buckhead. O. F. Kauffmann drew up the plat, and each of the 58 lots went on sale for $5,600. The neighborhood also had three churches, two grocery stores, two restaurants, and a blacksmith shop. It later became known as Bagley Park, named for Charlie Bagley, a prominent member of the neighborhood. In the mid-1940s, the Fulton County Commission condemned the neighborhood because a white neighbor did not want black people living behind his home. Between 1945 and 1952, the county bought Bagley Park, paying about $2.50 a lot, and then turned the area into a park. In 1980, the park was renamed Frankie Allen Park in memory of a police officer. (Courtesy of the Atlanta History Center.)

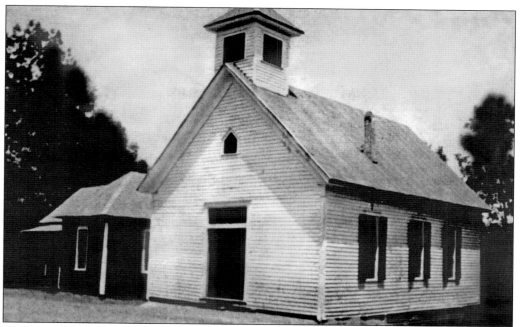

As the population grew around Moores Mill and Howell Mill Roads in the Cox's Crossroads community, also known as Minerva, Rosserville, and Rarytown, Center Congregational Church was established. The driving force is said to be Rev. Howell E. Newton, who organized the church in 1887. The congregation went from meeting in individual homes to meeting in a building on Howell Mill Road. In 1895, Harriet M. Cox deeded land to the trustees, and the building was moved onto the property. A small white frame church was built between 1897 and 1900, and a parsonage was later erected next door. The Reverend Lorenzo Dow Rolader served as pastor of the church for many years. Destroyed by fire in 1941, the church was rebuilt. The second photograph is of a tent meeting in July 1941 after the church fire. (Both courtesy of Center Congregational Church.)

Rosserville School opened in 1899 on Moores Mill Road in the Cox's Crossroads/Rosserville area. Many years later, the school building was converted into a four-unit apartment house, and it is said that one of the tenants was thought to be a prostitute. In 1957, St. Anne's Episcopal Church bought the property, and the red brick schoolhouse was remodeled into a church; the first service was conducted in February 1958. The building still exists and is one of the oldest buildings in Buckhead. The picture below is a 1934–1935 shot of the student body at Rosserville School. Notice the overalls and bare feet. (Above courtesy of St. Anne's Episcopal Church; below courtesy of William Haley.)

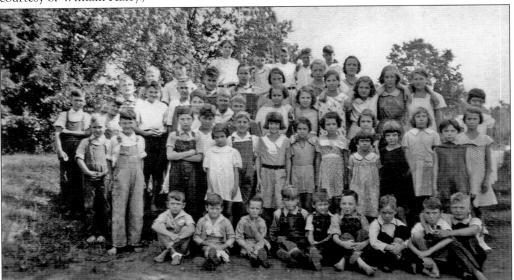

Four

CLANG, CLANG, CLANG CAME THE BUCKHEAD TROLLEY

1900–1913

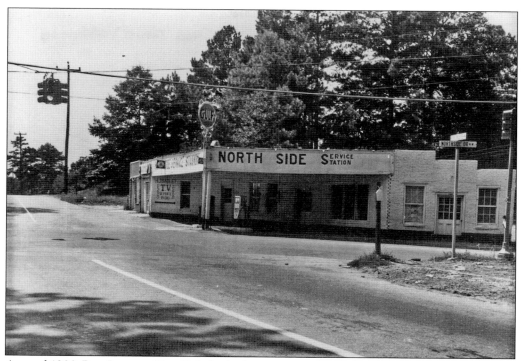

Around 1900, Rev. Lorenzo Dow Rolader built a grocery store at the corner of Moores Mill Road and Northside Drive. After World War I, he rented it to his nephew, Ivon Rolader, who operated it as the North Side Service Station, where he sold groceries and gasoline. Later it was also the Rolader Water Company office. In 1943, the minister's son-in-law, Joseph Tatum, took over the store. (Courtesy of Maybelle Tatum Osburn.)

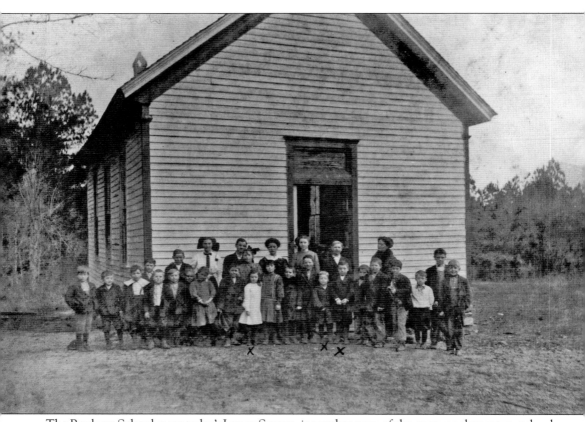

The Roxboro School, near today's Lenox Square, is another turn-of-the-century elementary school. It was located on North Druid Hills Road next door to J. W. Wright's property. It was probably a one- or two-room schoolhouse with one or two teachers teaching children of all ages. Eleanor Linn's grandfather was one of the students. (Courtesy of Eleanor Wright Linn.)

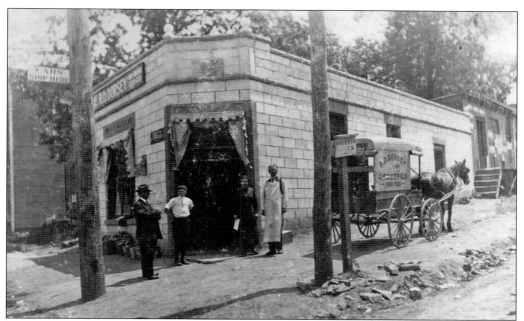

Robert Dorsey opened a "jot-'em-down" grocery store around the end of the 19th century on the corner of Peachtree and East Paces Ferry roads. Groceries were delivered to customers in his horse-drawn buggy. Although Dorsey had many wealthy clients, not all of them paid their bills. Consequently, he went broke and closed his business around 1907. (Courtesy of the Atlanta History Center.)

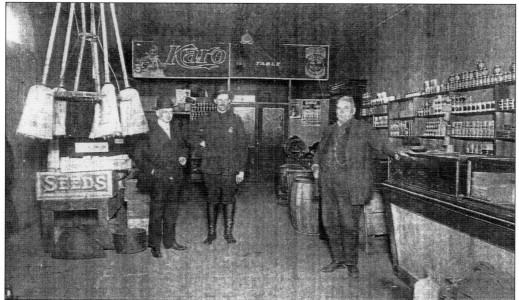

This is a picture of the inside of a typical turn-of-the-century "jot-'em-down" store. Items were stored in barrels, boxes, sacks, and tins. When customers came in and made a selection, the proprietor jotted the price down on a piece of paper, added up the purchases, then presented the bill. (Courtesy of Sara Cunningham Carpenter.)

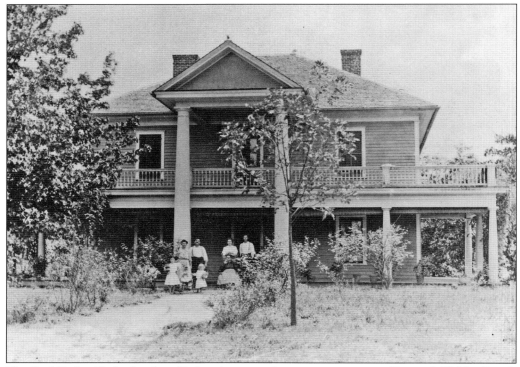

The Rial Bailey Hicks family sold their home at the present junction of Ivy and Old Ivy Roads around 1886 and moved to 2725 Peachtree Road, behind the present-day Garden Hills Theater. After Hicks died in 1902, his daughter Otella Mae and her husband, James Silvanus Donaldson, moved in to care for her mother. In this picture are Sarah Jane Hicks in her wheelchair, the Donaldsons (at left), and their children. (Courtesy of Gloria Donaldson Wells.)

James Sylvanus Donaldson was in the construction and road-building business. Around 1900, he built the Donaldson building on the former site of Henry Irby's tavern on Roswell Road at Peachtree Road. He also built the Buckhead Baptist Church on West Paces Ferry Road and graded and paved the first 2 miles of Habersham Road from Peachtree Battle Avenue. He is shown here with his wife, Otella Mae. (Courtesy of Gloria Donaldson Wells.)

Mary Ophelia Hicks (1858–1933), shown below at age 16, was the daughter of Rial Bailey and Sarah Jane Hicks. Rial Hicks had bought Land Lot 99 from his father-in-law, Henry Irby, for $4,000, and when his children married, he gave each 20 acres of land. When Mary Ophelia married Seaborn Lumpkin Ivey (1853–1937) in 1878, she and him were given land on what became Ivey Road (now Ivy Road). The couple had six children. Seaborn Lumpkin Ivey, shown here at around 20 years old, was the sixth child of Thomas Sanders Ivey and his wife Sarah Ann (Adcock). The Seaborn Iveys are buried in the Sardis cemetery. (Both courtesy of Sharon Matthews.)

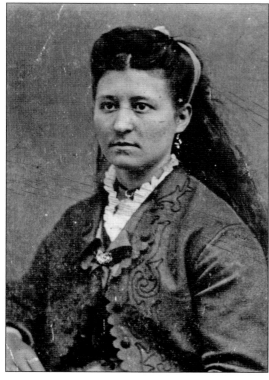

Mary Ophelia (Hicks) Ivey and her husband, Seaborn, built a home at 2737 Peachtree Road on land she inherited from her father. Seaborn operated a sawmill on the property. In 1919, they sold the home to Beverly DuBose Sr. and moved to Piedmont Road (now Peachtree-Piedmont Crossing Shopping Center). DuBose lived there about 20 years. The property is now Second Ponce de Leon Baptist Church's parking lot. (Courtesy of the Atlanta History Center.)

Eugene Russell Ivey (1857–1934), a son of Thomas and Sarah (Adcock) Ivey and brother of Seaborn L. Ivey, married Alice Virginia Hicks (1861–1901). She was a daughter of Rial Bailey Hicks and sister of Mary Ophelia Ivey. They lived on Ivey Road and had two daughters. He operated a timber mill and later owned and rented duplexes on Ivey Road. (Courtesy of Eleanor Eidson [Mrs. William J.] Foster.)

When the Russell Ivey's daughter, Selma Alabama (1882–1923), married Joseph Oscar Morris, they blended two families: her daughter, Alice Louise, and his son and daughter. They had three more children. Shown in this photograph are Selma and J. O. with their children. Louise (1902–2008), next to her mother, married William Jefferson Eidson Jr. and had two daughters. She lived in Buckhead until a few years before her death. (Courtesy of Eleanor Eidson Foster.)

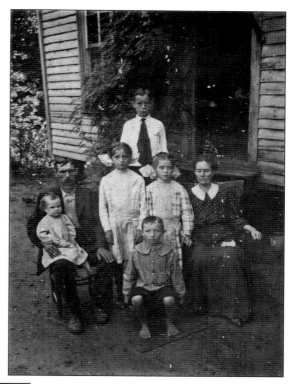

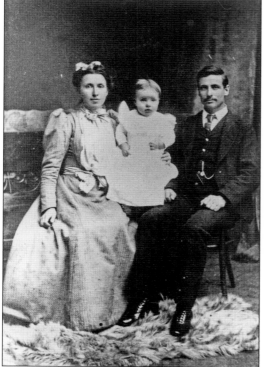

This photograph is of Mary Caroline "Callie" (Plaster) (1873–1964) with her husband, Joseph William Wright, and their son, Luther David. She was the daughter of Amanda Elizabeth "Lizzie" (Williams) and William Benjamin Plaster. William's maternal grandfather, Samuel Walker, farmed and operated a mill where Piedmont Park, the Piedmont Driving Club, and the Atlanta Botanical Gardens are now located. (Courtesy of Eleanor Wright Linn.)

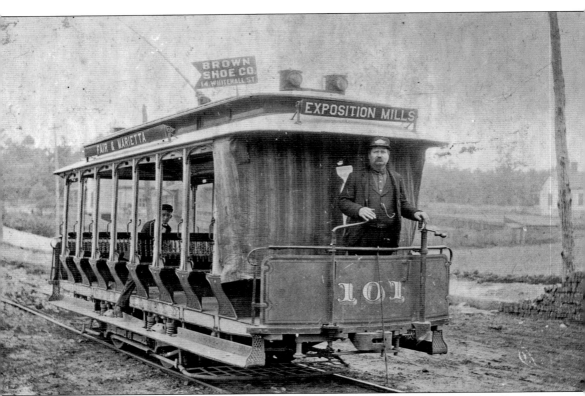

In 1907, the trolley line was extended to the heart of the Buckhead community. This allowed easy and inexpensive access to jobs and high schools in downtown Atlanta. Soon homes sprang up along Peachtree and West Paces Ferry Roads, and neighborhoods such as Peachtree Heights Park, Peachtree Hills, and Johnson Town were developed. The population of the community began to grow as friend followed friend to Buckhead. (Courtesy of the Atlanta History Center.)

Arthur Heyman's father came to America in 1852 from Prussia and settled in LaGrange, Georgia. Arthur graduated from the University of Georgia, became a lawyer, and moved to Atlanta. In 1896, he married Minna Simon and had two children, Joseph and Dora. In 1913, the family moved to Peachtree Road near Piedmont Road. Joe (seated at left) helped write the Plan of Improvement for annexing Buckhead into the City of Atlanta. (Courtesy of the Breman Museum.)

While recuperating from typhoid fever in his hometown in Kentucky, Jack Johnson Spalding (1856–1938) read law, then joined his father's law firm. He married Elizabeth Hughes, and in 1882, they moved to Atlanta; they had three children. Their first home was on Peachtree Street across from today's Colony Square. In the early 1900s, the Spaldings bought Reuben Arnold Sr.'s late-1880s Victorian Gothic-style home, with an unattached kitchen, in Deerland Park (site of Piedmont Hospital and the Battle of Peachtree Creek). They kept horses and cows and had a farm for growing vegetables and feed. Jack Spalding is responsible for widening Peachtree Road into an 80-foot boulevard. He cofounded the King and Spalding law firm in 1885. Active in politics, he was made a knight of Malta by Pope Pius XI. (Both courtesy of Van Shroeder Waddy.)

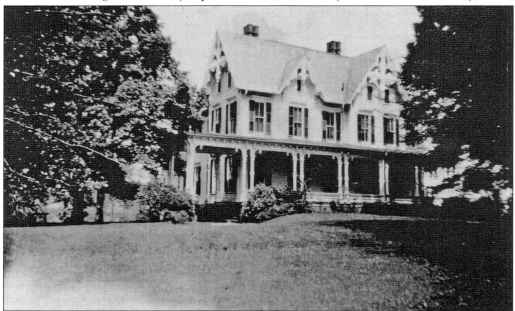

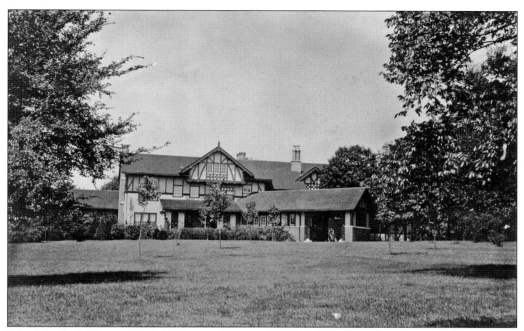

John Marshall Slaton (1866–1955) was the son of William Franklin Slaton, a Civil War veteran from Meriwether County and superintendent of the Atlanta Public Schools in 1870. John married Sarah Frances Grant, the daughter of William Daniel Grant. John served as president of the Georgia Senate and was elected governor in 1913. During this period, he became an integral force in the Leo Frank case. (Courtesy of the Atlanta History Center.)

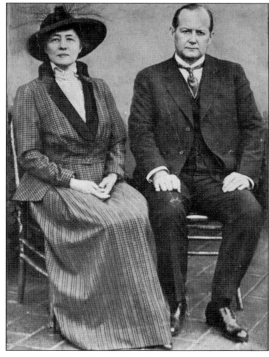

The Slatons built Wingfield, their Tudor-style house, on the west side of Peachtree Road at present-day Pharr Road. They operated a farm and had a riding rink for harness racing. When Slaton became governor (1913–1915), Wingfield became the Governor's Mansion. Following the governor's death in 1955, a fire severely damaged the house. The property was sold, and Slaton Manor apartments were built there in 1958. (Courtesy of the Atlanta History Center.)

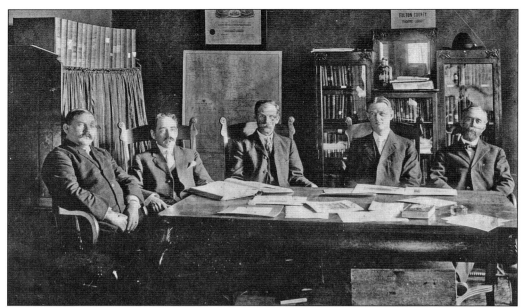

This picture of the Fulton County School Board meeting in 1904 or 1905 shows Dr. Robert Lawson Hope on the right. The doctor of homeopathic, manipulative, and herbal medicine was president of the Fulton County School Board that year. He was also the Fulton County Almshouse director and resident physician at the time. (Courtesy of Dr. Henry Hope.)

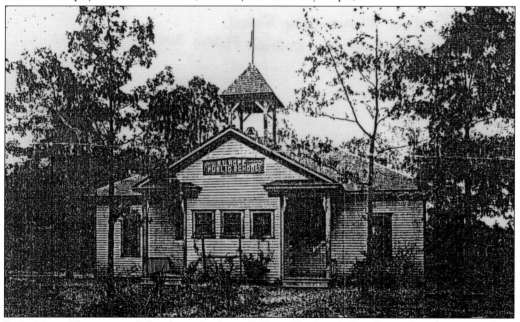

R. L. Hope Elementary School was built in 1909 on Piedmont Road near Peachtree Road on land donated by Dr. Lucien L. Hope. In the frame school building, four teachers taught children in two classrooms. Ida Williams was the school's first principal. Behind the school were a well and two outhouses. The building was replaced in 1925 with a large one-story red brick building. (Courtesy of the Atlanta Public Schools.)

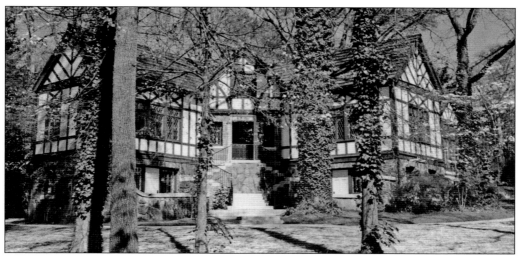

In 1910, Walter Pemberton Andrews built a stucco and half-timbered English-style home on Peachtree Road. John Grant Sr., wanting a road from his home on West Paces Ferry south to Peachtree Road, offered to buy part of Andrews's property. When Grant suggested naming the road Andrews Drive, Andrews gave him the land. The estate was sold in the 1920s, and the house was repositioned to face Andrews Drive. (Courtesy of author.)

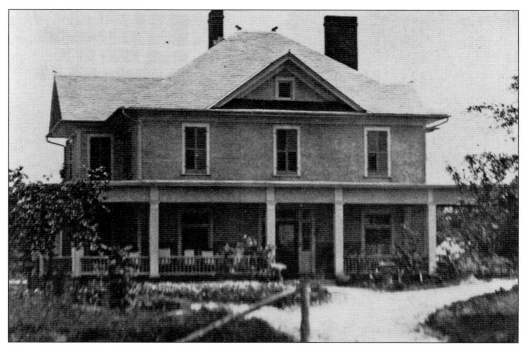

Dr. Methvin T. Salter (1862–1931) built his family home and operated a small farm on Peachtree Road in 1910 on the site of the present Maier and Berkele Jewelers. Dr. Salter graduated from Atlanta's College of American Medicine and Surgery then joined his father, Dr. Seaborn Freeman Salter, in his dispensary and mail-order service. They practiced "reform" medical treatment that advocated using native plants or special palliatives to cure diseases. (Courtesy of the Atlanta History Center.)

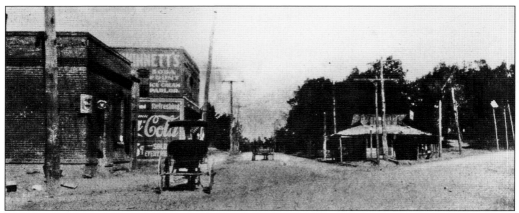

This 1910 picture is the first of the center of today's Buckhead Village. The buildings on the left sit on the former site of Henry Irby's Tavern. Axson Minhinnett rented the building on the right, built by James Sylvanus Donaldson, for a general store and soda fountain. The unpaved road on the left is Roswell Road, and in the center is George Brumbelow's blacksmith shop. Peachtree Road is on the right. (Courtesy of the Atlanta History Center.)

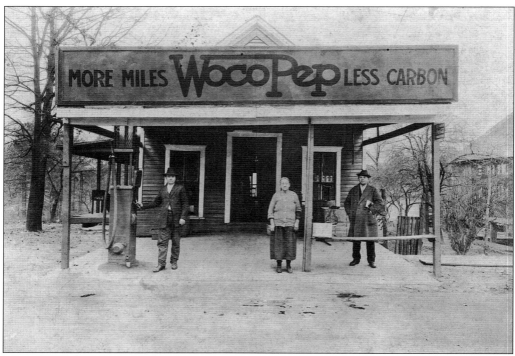

Harrison Anderson operated a grocery store in a small wooden building on the southeast corner of Peachtree and Pharr Roads from around the beginning of the 20th century until the 1940s. When cars became popular, he installed a gas tank in the front. Anderson was killed in the 1940s after being struck by a car while crossing Peachtree Road. His business was across the street from Gov. John Slaton's home. (Courtesy of Caroline Laudermilk.)

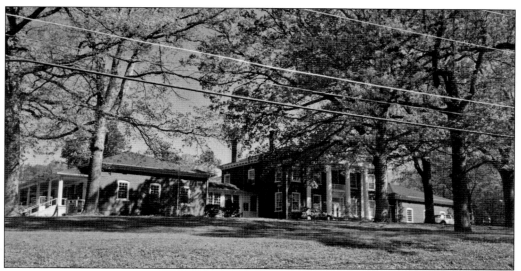

Fulton County built two almshouses in 1911 on Wieuca Road (now Chastain Park) to shelter the poor. Morgan and Dillon designed the two-story, red brick building with a neoclassical-style front colonnade for the white citizens of the county. The almshouse, known as Haven House, closed in 1968. In 1969, Elliott and Kitty Galloway and Ross Arnold leased the building for their new Galloway School. (Courtesy of author.)

Next door was the almshouse for black citizens. Morgan and Dillon also designed this single-story, white frame house with front and side porches. The county's female prisoners lived in a building at the rear that was connected by a breezeway. On the present Chastain golf course, the prisoners grew vegetables for the almshouses and for other prisons. Male prisoners were housed on top of the hill overlooking the farm. (Courtesy of author.)

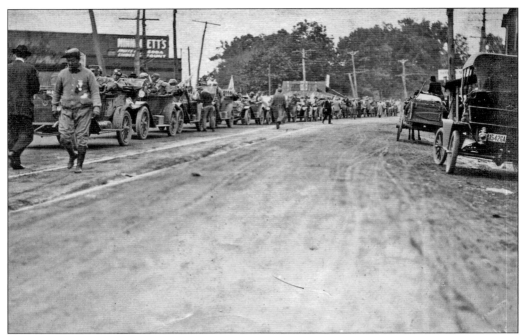

In 1911, the Glidden Motor Tour parade traveled south from New York City to Jacksonville, Florida. Its route took it down Peachtree Road and through the center of today's Buckhead Village. A horse and wagon, a more popular mode of transportation of the day, can be seen going north. In front is the Brumbelow blacksmith shop, and to the left is a sign advertising Minhinnett's store. (Courtesy of the Atlanta History Center.)

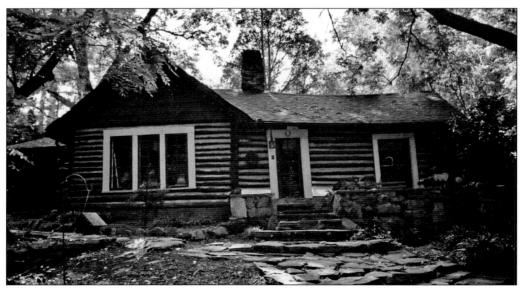

Early Buckhead was once a pristine forest where game such as deer was hunted. Still tucked away in the woods near Phipps Plaza and behind multiple homes and condominiums sits a turn-of-the-century hunting lodge thought to have been owned by an Atlanta mayor. This jewel of a log cabin, with overhead beams and a stone fireplace, is now a private home. (Courtesy of author.)

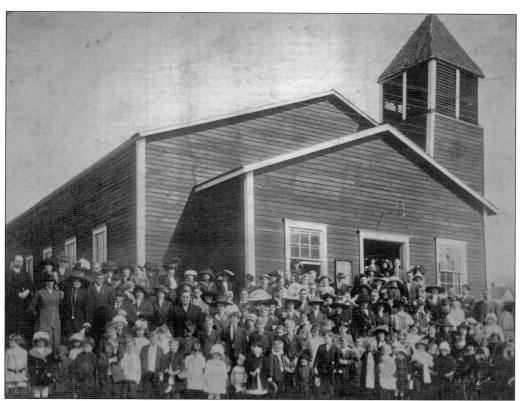

The white clapboard Buckhead Baptist Church sanctuary was once located on West Paces Road near Peachtree Road, on the present-day site of Buckhead Market Place. It was constructed under the direction of James Sylvanus Donaldson. It was dedicated in 1911, and it looks like the entire congregation posed for this photograph around that time. The second picture shows the church group enjoying a picnic. When the congregation outgrew the church facilities, Sunday school classes were held in various buildings around Buckhead. The church merged in 1932 with Ponce de Leon Baptist Church, which through other mergers became Second Ponce de Leon Baptist Church. (Courtesy of Eleanor Eidson [Mrs. William J.] Foster.)

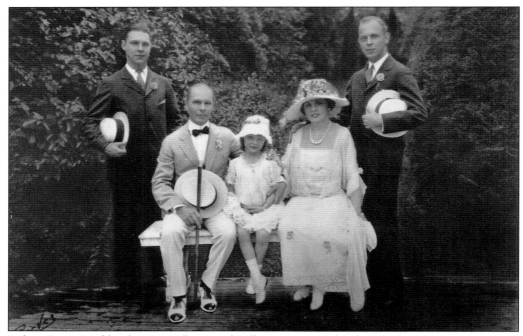

Robert Foster Maddox (1870–1965) married Lollie Baxter, and they had three children. He founded the Maddox-Rucker Banking Company in 1879, was president and chairperson of the board of First National Bank, and served as mayor of Atlanta from 1909 to 1910. In 1904, he bought 75 acres of land from his friend James Dickey on West Paces Ferry Road for $6,578 and built a summer home and operated a farm. In 1911, he built an English Tudor-style home for $60,000 that he called Woodhaven. After his death, the estate was sold to the State of Georgia. The house was torn down, and in its place sits the Greek Revival–style Georgia Governor's Mansion. In the family picture above are, from left to right, N. Baxter Maddox, Robert F. Maddox, Laura Maddox (Spearman), Lollie Maddox, and Robert F. Maddox Jr. (Above courtesy of Laura Smith Spearman; below courtesy of the Atlanta History Center.)

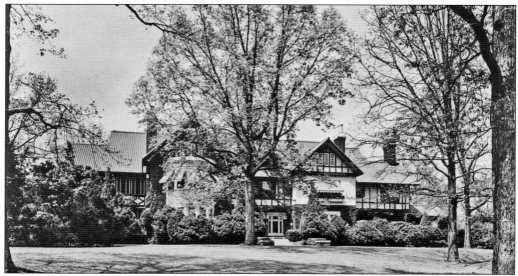

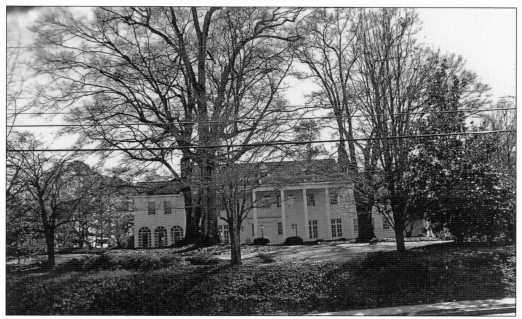

James L. Dickey (1847–1911) bought 405 acres of land on West Paces Ferry Road in 1903 from Dr. James H. Smith's widow for $6,000, or $15 an acre. He first built a cottage on the property. Then, in 1911, he replaced it with a replica of George Washington's Mount Vernon, which he named Arden. Dickey was a retired official of the Western and Atlantic Railroad. (Courtesy of author.)

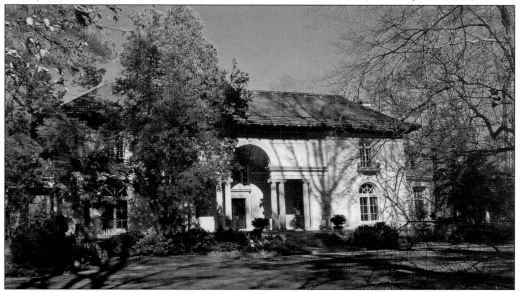

Former Florida congressman William Bailey Lamar and his wife, Ethel, built a home at 801 West Paces Ferry Road on 200 acres of land that was once the site of the home of Hardy Pace, who operated a ferry named Pace's Ferry. They called their home Villa Lamar. They moved to Washington D.C. in 1914, and Sanders McDaniels bought the property. In 1958, it was subdivided, and Kingswood Subdivision was created. Reuben Garland Sr. bought the house and renamed it Newcastle. (Courtesy of author.)

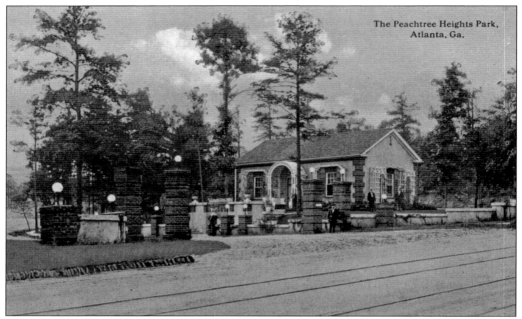

The Peachtree Heights Park,
Atlanta, Ga.

In 1911, Eretus "E" Rivers and Walter P. Andrews began developing the Peachtree Heights Park neighborhood around Peachtree Battle Avenue on the west side of Peachtree Road. A park in the middle of a portion of Peachtree Battle Avenue divides the road, setting off the beautiful homes. The small house to the right of this picture served as the office of Rivers and Andrews. (Courtesy of the Atlanta History Center.)

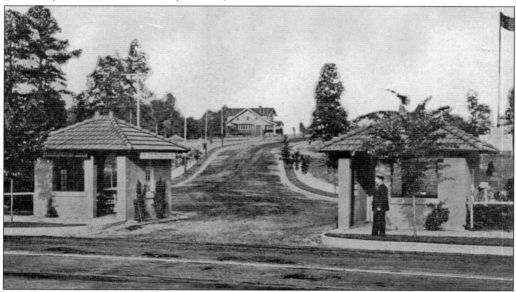

Sixty-one acres of the Benjamin Plaster estate were sold in 1911 to American Securities Company of Georgia. This property on the east side of Peachtree Road was subdivided, and Peachtree Hills Place was developed for homes. After later merging with Peachtree Terrace and Peachtree Hurst subdivisions, the area became known as Peachtree Hills. Shown is the Peachtree Road entrance. (Courtesy of the Atlanta History Center.)

In 1890 and 1891, the Suburban Land Improvement Company established the Peachtree Park Subdivision across from the present Lenox Square and attempted to sell 243 lots. It met with poor success. In 1912, Columbus and Callie Johnson, a black South Georgia couple, purchased 15 lots from D. N. Williams for $600 and in turn sold the lots to other blacks in the area. The new community became known as Johnson Town, and before long, it was filled with modest bungalows and shotgun houses built along unpaved streets. These houses, on Oak Valley Road and Railroad Avenue, were typical homes in the community. Because there was no indoor plumbing, privies were located in the backyards. (Both courtesy of the Atlanta History Center.)

Some of the members of the Johnson Town community were entrepreneurs. They operated grocery stores and nightclubs. One such enterprising resident was Henry Walker, who operated Henry Walker's Restaurant and Grocery Store at 937 Railroad Avenue. His popular nightspot provided music, dancing, and drinks for his patrons. Walker also owned apartment buildings and duplexes. He was considered one of Johnson Town's most prominent citizens. The Zion Hill Baptist Church served the religious needs of the Johnson Town residents and those living in the surrounding black neighborhoods. The white wood-frame building was built around 1912 and was located on Railroad Avenue. The church affiliation was originally Methodist, but it later became a Baptist church. (Both courtesy of the Atlanta History Center.)

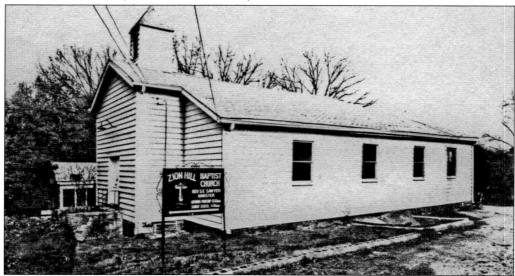

Five

LEO FRANK AND THE KU KLUX KLAN

Leo Frank moved to Atlanta from New York and married Lucile Selig. He became the National Pencil Company plant manager. On April 26, 1913, young Mary Phagan went to the company to collect her wages. Later, her raped and strangled body was discovered in the basement. James Conley, a black janitor with a criminal record, was arrested. He accused Frank, who was arrested and tried in an atmosphere filled with anti-Semitic rhetoric. He was convicted and sentenced to death. Gov. John M. Slaton reviewed the records and commuted the sentence to life in prison. Frank was transferred to Milledgeville State Prison then abducted by the Cobb County "Knights of Mary Phagan," who took him to Marietta to be hanged. Alonzo Mann, shortly before his death, admitted to seeing Conley carrying Mary's body. Leo Frank was pardoned in 1986. (Courtesy of the Breman Museum.)

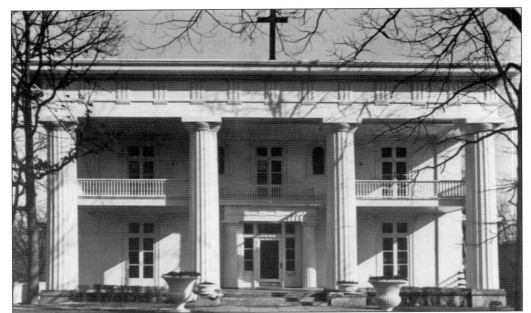

Because of the Leo Frank case, the Ku Klux Klan raised its ugly head in 1915 after hibernating since 1877. Membership grew quickly, and Buckhead became its local headquarters. The Klan bought the Edward M. Durant property on Peachtree Road (now the Cathedral of Christ the King) in 1921 and established its command center in the beautiful two-story, antebellum-style home they called the Imperial Palace. (Courtesy of the Cathedral of Christ the King.)

A Mr. Coleman built this three-story building on Roswell Road in 1920 in the heart of Buckhead, and deeded it to the Knights of the Ku Klux Klan. It became their sheet factory, where the members' robes and hoods were made. Upstairs, there was a secret room used to initiate new members. The factory operated until 1929, when Klan activity waned. Today it is the Cotton Exchange office condominium. (Courtesy of author.)

Six
THE TEENAGE BUCKHEAD
1914–1919

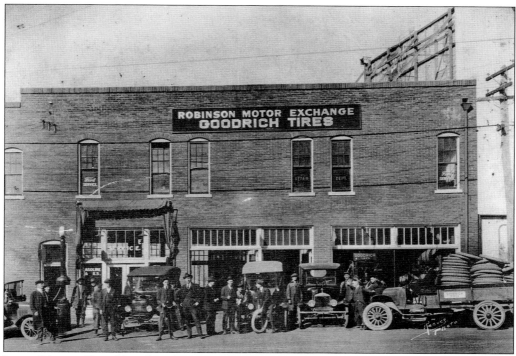

James Silvanus Donaldson bought some of Henry Irby's property where Irby's tavern once stood. In 1900, the tavern was torn down, and Donaldson constructed a building that fronted Roswell Road at Peachtree Road. At one time, the Robinson Motor Exchange occupied the building. It specialized in selling Goodrich Tires and servicing automobiles in need of its product. To the left of the picture is an early gasoline pump. (Courtesy of Eleanor Eidson [Mrs. William J.] Foster.)

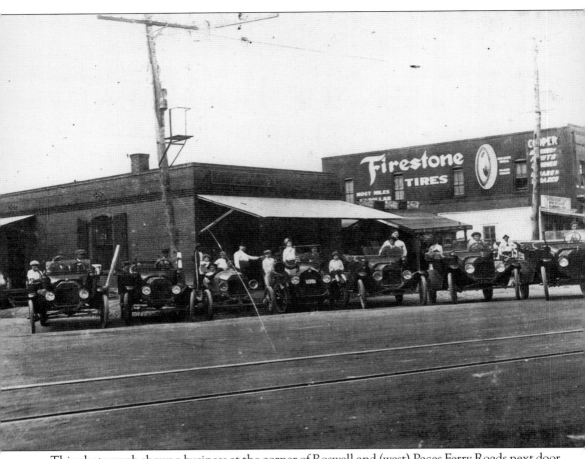

This photograph shows a business at the corner of Roswell and (west) Paces Ferry Roads next door to the Robinson Motor Exchange. (Courtesy of Eleanor Eidson [Mrs. William J.] Foster.)

James J. Haverty (1858–1939), the youngest of 10 children of Thomas and Margaret (Canaan) Haverty, emigrated from Ireland to Atlanta around 1852. He founded Haverty Furniture Company in 1885 and merged it with Amos G. Rhodes's furniture store, becoming Rhodes-Haverty Furniture Company from 1888 to 1909, when it again became Haverty Furniture Company. He bought 6 acres of land on Peachtree Road and in 1916 built Villa Clare, which he named for his wife, Clare (Malone); now it is the site of Shepherd Spinal Center. Their son, Clarence (1881–1960), worked for his father after graduating from high school. In 1938, Clarence became president of the business. Clarence, shown here, was active in civic affairs and was an Atlanta councilman (1912–1913). In 1946, Pope Pius XII appointed him Private Chamberlain of the Sword and Cape. He and wife, Elizabeth (Rawson), had three children. (Both courtesy of Elizabeth Haverty Smith.)

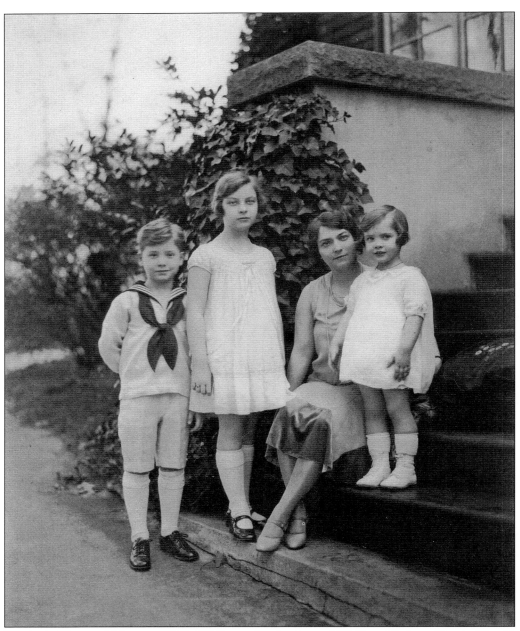

Elizabeth (Rawson) Haverty (1889–1986) was the daughter of William Clark and Lucia (Brock) Rawson. William was with F. I. Stone Company and was an organizer of Elizabeth Cotton Mill. After graduating from Washington Seminary, Elizabeth attended the Finch School in New York. Following her Atlanta debut, she attended a French school in Washington. She married Clarence Haverty in 1912. From left to right are James Rawson Haverty, Clare Malone Haverty, Elizabeth Rawson Haverty, and Elizabeth Rawson (Betty) Haverty Smith. (Courtesy of Elizabeth Haverty Smith.)

Clarence and Elizabeth Haverty moved to 2734 Peachtree Road at Andrews Drive from their home on Piedmont Road. Two-year-old Clare Malone, the oldest of the Haverty children, is shown in the front yard of their home in 1919. Of particular interest is the streetcar heading south on Peachtree Road. On the hill in the upper left of the picture is the future site of the Cathedral of St. Phillip. (Courtesy of Elizabeth Haverty Smith.)

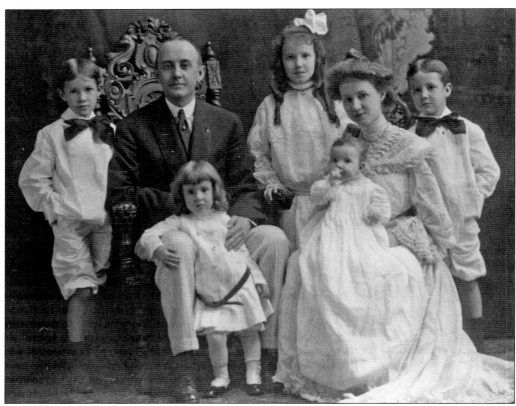

John W. Grant Sr. (1867–1938) was a large property owner who built some of Atlanta's downtown buildings. He married Annie Inman, one of Hugh T. Inman's daughters, and they had five children. Grant was also a leader in the cultural, business, and civic life of Atlanta. Between 1914 and 1917, the Grants built a large stucco-and-limestone English Country–style home on West Paces Ferry Road, pictured below, that they named Craigellachie for a town in Scotland. They also operated a farm on the property. Their son, Hugh, died in 1906, when he was about 10 years old. In 1913, the Grants donated money to Georgia Tech that was used to buy land and to build a stadium in Hugh's memory. In 1956, a group of people organized the Cherokee Town and Country Club, rented Craigellachie, and later bought it for $200,000. (Above courtesy of John W. Grant III; below courtesy of author.)

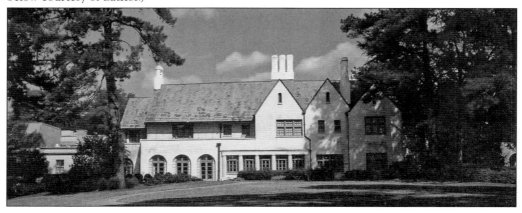

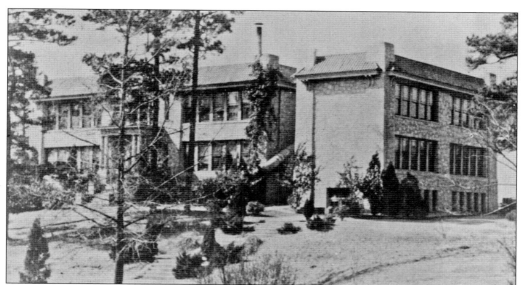

Eretus "E" Rivers was one of the developers of the Peachtree Heights Park neighborhood in 1911. He later donated a piece of land at the southeast corner of Peachtree Road and Peachtree Battle Avenue for an elementary school. In 1917, the three-story gray stone schoolhouse opened as Peachtree Heights Elementary School, but it was renamed E. Rivers School in 1926 in honor of Rivers's donation and because he had served on the Fulton County Board of Education. One Saturday in September 1948, the school was destroyed by fire. The culprit was a blowtorch-wielding janitor trying to get rid of wasp nests in the building. A contemporary school building was built in its place. The photograph below, showing the fourth and fifth graders, was taken on the steps of the original school. (Above courtesy of the Atlanta History Center; below courtesy of Dr. Phinizy Jr. and Mary Ellen Calhoun.)

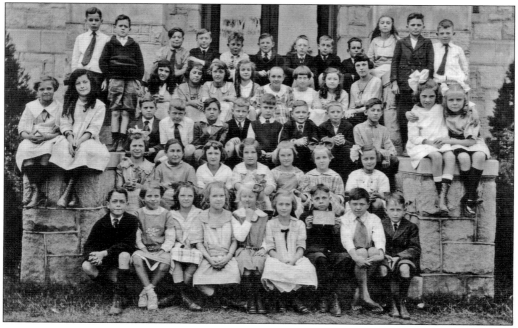

Dr. Ferdinand Phinizy Calhoun Sr., a well-known Atlanta ophthalmologist, was the son of Dr. and Mrs. Abner Welborn Calhoun. The Newnan, Georgia, native graduated from the University of Georgia, Harvard, and Atlanta Medical College. He married Marion Compton Peel, daughter of William Lawson Peel, at Peel's home on Peachtree Road (present site of the Temple). The couple had two sons, Phinizy Jr. and Lawson. In 1917, the Calhouns built the first house on Andrews Drive at number 2906. At the time, his land was part of Peachtree Heights Park neighborhood. The Tudor-style house was originally called Shadow Hill but was renamed Rossdhu after an ancestral home in Scotland. On their 7 acres of land, they operated a small farm. (Above courtesy of the Atlanta History Center; below courtesy of author.)

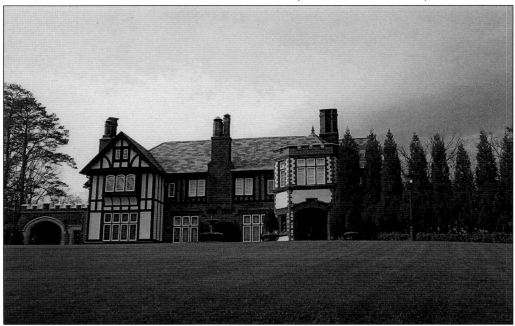

Seven

BUCKHEAD BUILDS AND RECREATES
1920s

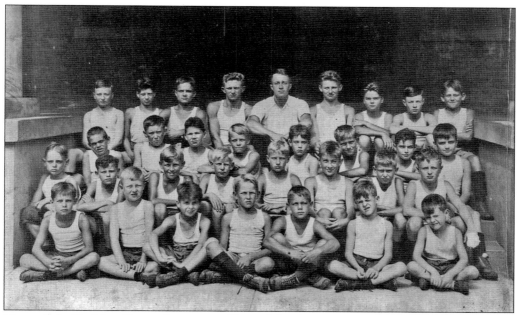

Many of the Buckhead boys who went to Camp Ashnoka grew up to become some of Atlanta's and Buckhead's most prominent citizens. Located at the Asheville, North Carolina, School for Boys, it featured an array of sports activities, such as swimming and baseball. Of particular note in this 1920–1921 photograph is Ivan Allen Jr. (third row, fourth from the left), who later became mayor of Atlanta. (Courtesy of Sam Dorsey.)

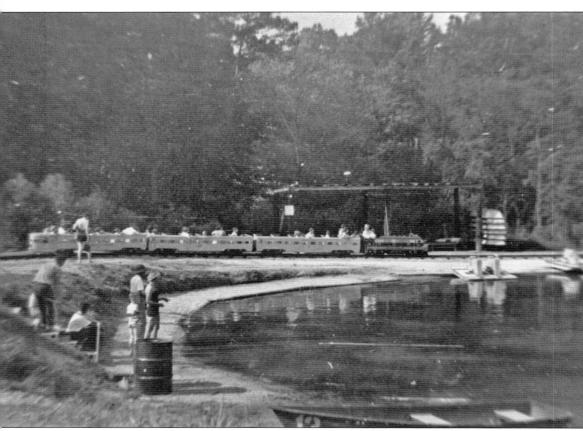

Deuward S. Mooney developed Mooney's Lake, a popular recreational spot in Buckhead, in 1920. It was located behind what later became Lindbergh Plaza Shopping Center. There were two spring-water pools, a lake for swimming and canoeing, horseback riding, miniature golf, and a railroad. Food was sold at the pavilion, and guests danced to jukebox music. After the pavilion burned down in the late 1950s, Mooney went out of business. (Courtesy of Georgia Archives, Vanishing Georgia Collection, ful0944-85.)

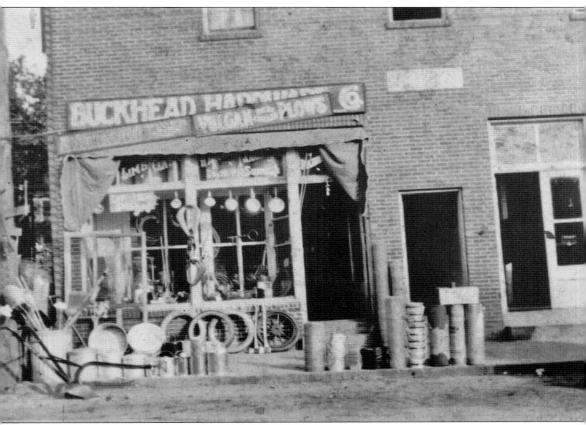

George P. Murray opened the first hardware store in Buckhead in 1921 in the 2900 block of Peachtree Road, just north of East Paces Ferry Road. At the time, there were seven brick buildings in Buckhead. In 1929, Murray bought a wooded lot one block south and built a new hardware store, which opened the following year. By 1934, the block was completely developed. Buckhead Hardware closed in 1998. (Courtesy of Tom Murray.)

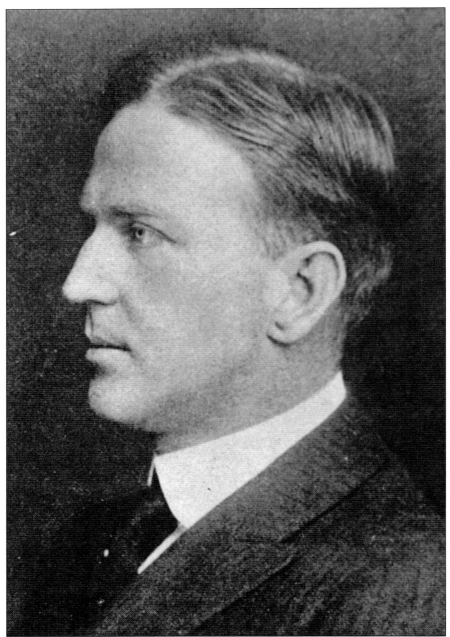

Phillips Campbell McDuffie (1885–1965) was a native of Henderson, North Carolina, and the son of a Baptist minister. He worked his way through Harvard Law School, where he met Fred Loring Seely, who had built Grove Park Inn in Asheville, North Carolina, and who founded the *Atlanta Georgian* newspaper in 1906. Seely induced McDuffie to move to Atlanta by offering him a job at the newspaper. McDuffie met and married Helen Walker Bagley. In 1923, McDuffie built a two-story brick building on the site of Henry Irby's Tavern at the corner of West Paces Ferry and Roswell Roads on land he leased from the James Slyvanus Donaldson family. In 1925, he developed the Garden Hills neighborhood. (Courtesy of Helen McDuffie.)

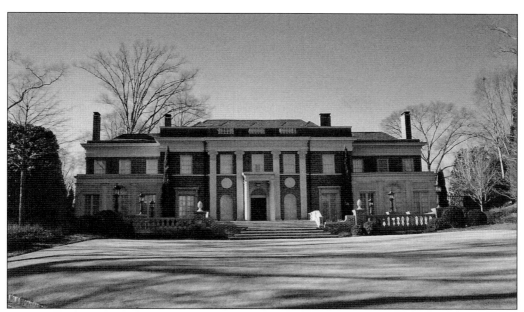

Phillips and Helen (Bagley) McDuffie built a home (above) at 7 Cherokee Road around 1920 for themselves and their children, Phillips Jr. and Helen. They drew up the plans for the house and worked closely with architect Neel Reid. In the rear of the home was a formal garden with a beautiful gazebo. Helen McDuffie's father, Henry Clay Bagley, was once the largest peach grower in the state and was in the logging business. He went to North Georgia and named the town of Helen for his daughter. Shown below on the wagon is the McDuffie's young daughter, Helen. (Above courtesy of author; below courtesy of Helen McDuffie.)

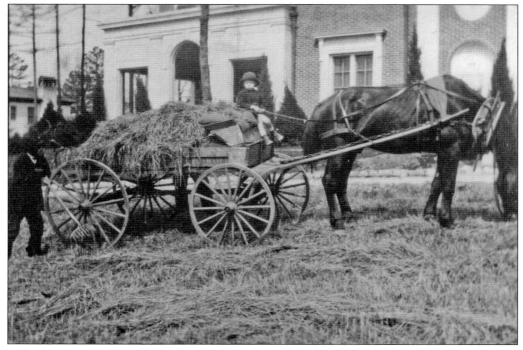

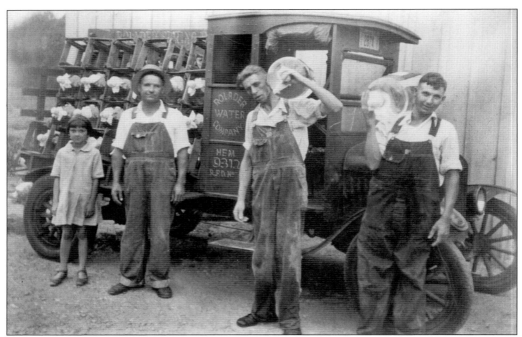

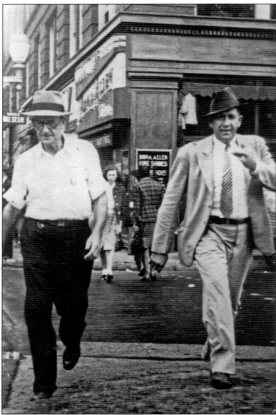

Brothers Ivon, Clark, and Homer Rolader founded the Rolader Spring Water Company in the mid-1920s. Water was gathered from springs located off West Paces Ferry Road in what is now the Kingswood subdivision. The water was placed in 5-gallon jugs that were corked and sealed. They were carried by trucks, sold to downtown office buildings, and inverted into coolers. The picture below was taken in the 1930s on a street in downtown Atlanta and shows Ivon Rolader (right) and Reuben Morris (left). Reuben Morris operated a dairy on Moores Mill Road from the late 1930s into the 1940s. (Above courtesy of Dan Vickers; below courtesy of Weyman Brown.)

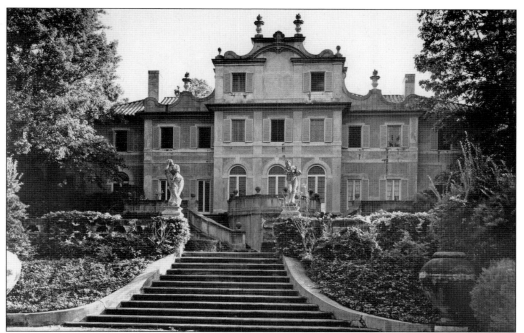

In 1923, the Andrew Calhoun family built their home on West Paces Ferry Road. Architect Neel Reid designed the pink Baroque-style house called Trygveson, which the public dubbed the Pink Castle. After Calhoun's death, his daughter, Louise, and her husband, Roby Robinson Jr., moved into the home. They died in the 1962 Orly plane crash in Paris, France. The property was subdivided, and Pinestream Road was cut through to Northside Parkway. (Courtesy of the Atlanta History Center.)

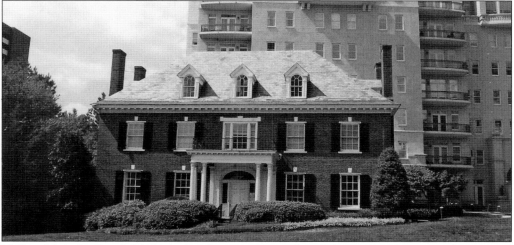

Hollins Nicholas Randolph built this Georgian Revival–style home in 1924 on Peachtree Road at Lindbergh Drive. The house, designed by P. Thornton Marye, was later bought by Atlanta movie theater pioneer Arthur Lucas and his wife, Margaret. Upon their death, a member of the Story family inherited the home. Urban developers bought the property in 1997, moved the house forward and south, and then built the 2500 Peachtree condominium development. (Courtesy of author.)

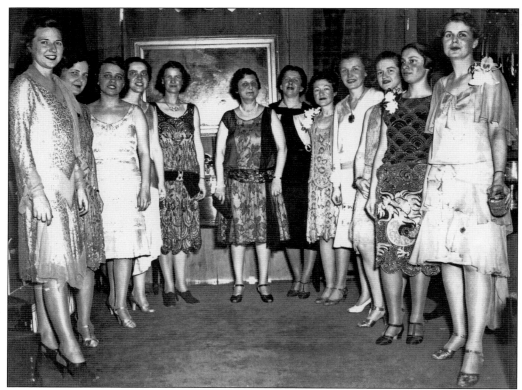

This is a photograph of some of the Buckhead ladies, which was taken at a social event in the 1920s. Of particular note are, at far left, Nancy Fredrick (Mrs. Robert Pegram), Martha Pritcherd (Mrs. Morris Brandon) (third from left), and, at far right, Rachel Neely (Mrs. John Ottley Jr.). (Courtesy of John Ottley Jr.)

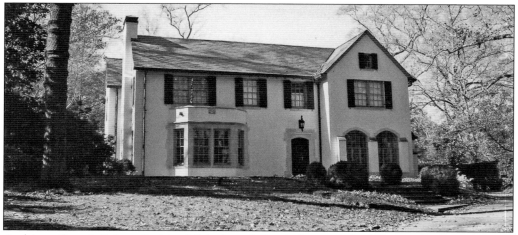

Architect Francis Palmer Smith of Pringle and Smith designed this home in 1923 on Andrews Drive for the William Ott Alston family. The carriage house was built first and served as the family's home during construction of the house. In 1938, Russell and Catherine (Haverty) Bellman bought the property. Thirty years later, they sold it to the John Mauldin family, who in turn sold it in 1987 to U.S. senator Paul Coverdell and his wife, Nancy. (Courtesy of author.)

Peachtree Presbyterian Church began in 1910 with a Sunday school program organized as a memorial to the child of Mr. and Mrs. C. S. Honour. This led to the establishment of the church in 1919. In 1926, the congregation began meeting in their new, gray-granite sanctuary at the corner of Peachtree Road and Mathieson Drive. (Courtesy of Peachtree Presbyterian Church.)

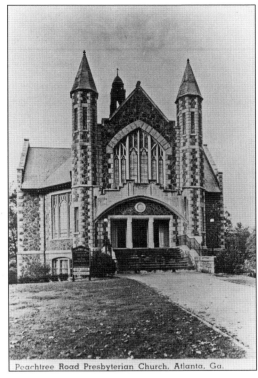

Peachtree Road Presbyterian Church, Atlanta, Ga.

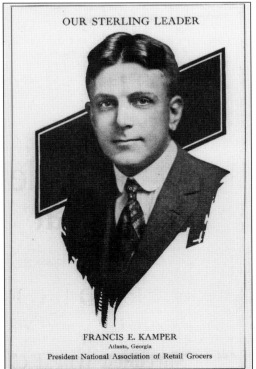

OUR STERLING LEADER

FRANCIS E. KAMPER
Atlanta, Georgia
President National Association of Retail Grocers

Charles Joseph Kamper came to Atlanta from Buffalo, New York, in 1872 and opened Kamper's Grocery Store on Peachtree Street at Ivy Street (today's Crawford Long Hospital). Groceries were delivered to his customers by horse and wagon. Francis E. Kamper joined his father in the business. In 1925, Kamper's Grocery Store opened in Buckhead on Peachtree Road between Pharr Road and Peachtree Avenue. Francis, seen here in 1925, married Vera Reins. (Courtesy of Betty Kamper Miller.)

In 1925, Phillips C. McDuffie developed the Garden Hills neighborhood plan, which was to include the development of homes, apartments, schools, shops, and parks. It was touted to be the "Garden Spot" of Atlanta's residential section. The average lot sold for $2,750. By the end of the year, five houses had been built on or near Rumson Road. On Peachtree Road, McDuffie built the Alhambra apartments in 1927. The photograph above is of a home of classic Georgian design built in 1932. Below are the Alhambra apartments. In 1987, the U.S. Department of the Interior named Garden Hills to the National Register of Historic Places. (Both courtesy of author.)

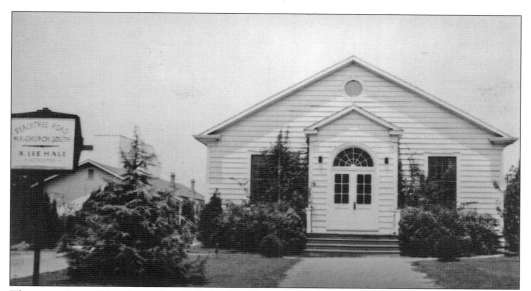

The organizers of Peachtree Road Methodist Church purchased a lot on Peachtree Road at Sardis Way for $15,000 and built a white wooden sanctuary. The first services were held in June 1925. In 1941, they bought a lot at 3180 Peachtree Road, moved the sanctuary, and used it while the Colonial-style Great Hall was being built. Today the International House of Pancakes sits on the original lot. (Courtesy of Peachtree Road Methodist Church.)

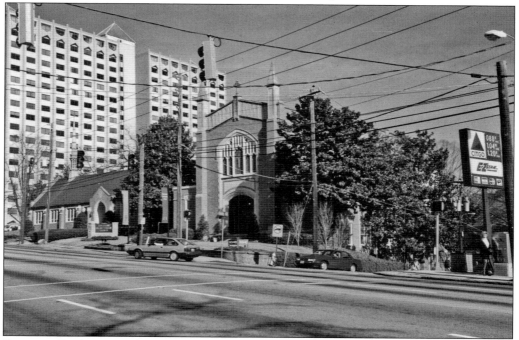

Covenant Presbyterian Church had its beginnings in 1874 in downtown Atlanta. Lacking support, it closed in 1877. It was reestablished in 1901 and became Harris Street Presbyterian Church in 1907. When it moved into its Gothic-style building on the corner of Peachtree Road and Terrace Drive in Buckhead in 1926, it became Covenant Presbyterian Church. (Courtesy of author.)

Fred Leon Rand was an architect with Pringle and Smith. He later went into business for himself and called his new firm Rand and Company. Rand designed and built a two-story, Georgian Colonial home for himself, his wife, and two children on Piedmont Road near the present Buckhead Loop in 1926. The home was called Leighton after Rand's hometown in Alabama. At the time it was built, Piedmont Road was a high-crowned, two-lane road with little traffic. In the backyard, the family had a tennis court, which they turned into a victory garden during World War II. (Both courtesy of Alva and Mildred Lines.)

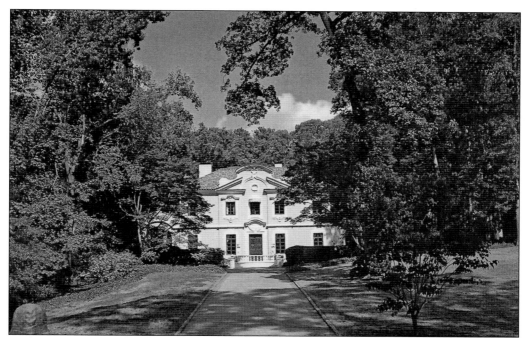

Architect Neel Reid designed a pink stucco Italian Baroque–style villa for Joseph D. Rhodes, son of furniture magnate Amos G. Rhodes. The home at the corner of West Paces Ferry and Tuxedo Roads was completed in 1926 and became known as Santa Stae. Rhodes' niece, Mrs. James D. Robinson (Josephine Crawford), inherited the house. There have been several owners of this home, which is now beige in color. (Courtesy of author.)

In 1926, Consolidated Cabaret built Peachtree Gardens Dance Hall at the intersection of North Ivey and North Stratford roads. General contractor Theodore J. Benning held the property deed. When the company failed to pay him, he took ownership and leased the hall. During the Depression, Club Quadrille, formed by people who dropped private club memberships, met there. Later schools and private groups rented the hall until it closed in late 1980. (Courtesy of Theodore J. Benning Jr.)

Architect Charles Hobson designed this house in 1927 for Charles and Fannie (Lamar Rankin) Gately on West Paces Ferry Road (now Paces Forrest Road). The Gatelys occupied the carriage house while their house, which they called Isola, was being built. After Fannie Gately's death two years later, the house remained vacant until Charles and Adeline Loridans bought it in early 1940 and renamed it Loridans. (Courtesy of author.)

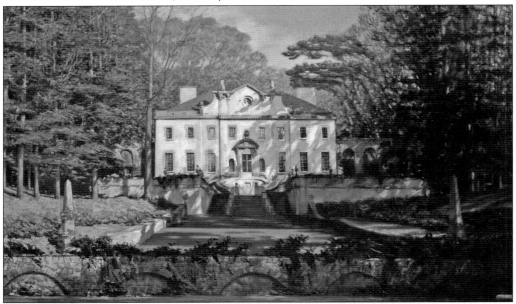

In 1928, Edward H. and Emily Inman built a home called Nevera on Andrews Drive. Designed by Philip Trammell Shutze, it was renamed the Swan House because of the many swan motifs. After Emily's death in 1965, the Atlanta Historical Society purchased the property. Today the Swan House and the 1830s Tullie Smith House are the centerpieces of the Atlanta History Center. (Courtesy of the Atlanta History Center.)

John King Ottley (1868–1945) and his wife, Passie, moved in 1890 from Missouri to Atlanta, where he became an assistant cashier at American Trust. Over the years and through several mergers, it became the First National Bank (1929), and he became president and then chairman of the board. His home, Joyeuse, sat on 87 acres that is now the site of Lenox Square. Shown here are Ottley Sr., Jr., and III. (Courtesy of John K. Ottley Jr.)

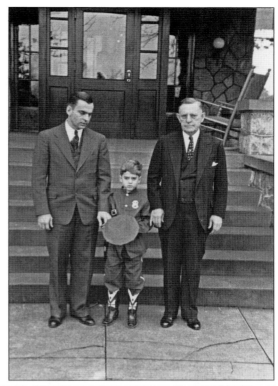

Horseback riding was the vogue in Buckhead in the 1920s and 1930s. The Saddle and Sirloin Club enjoyed early morning rides along paths that traversed the woods around West Paces Ferry, Habersham, and Argonne Roads. In this 1928–1929 photograph are, from left to right, Clark Howell, Morris Brandon Jr., Trammel Scott, William Kiser, Mrs. Howell, Inman Brandon, Morris Brandon Sr., Mac Tucker, John Ottley, Albert Howell, and Robert Harvey. (Courtesy of John K. Ottley Jr.)

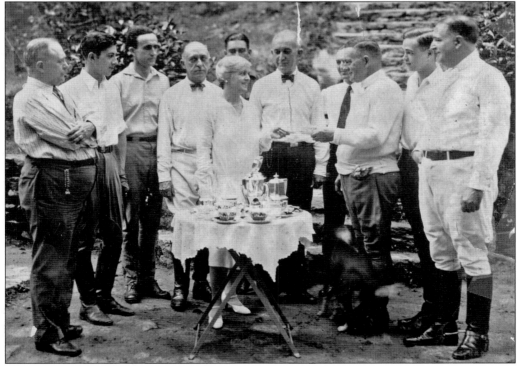

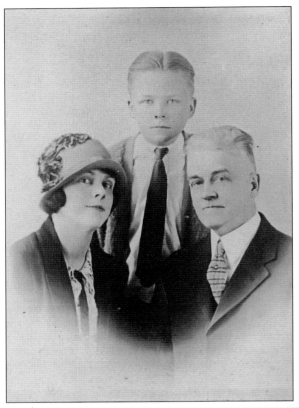

Ivan Ernest Allen, son of Susan and Daniel Ernest Allen, was born in 1877 in Dalton, Georgia. He moved to Atlanta in 1895 and became a $40-a-month typewriter salesman. In 1900, he opened the Fielder and Allen office equipment store, which today is the Ivan Allen Company. He married Irene Susannah Beaumont, and they had one child, Ivan Jr. Some of his civic activities included organizing the Atlanta Retail Merchants Association, the Atlanta Chamber of Commerce, and the Boy Scouts of Atlanta and raising money to build Oglethorpe University. He was a state senator and chairperson of a commission overhauling the state government. In 1927, Allen moved his family to their Tudor-style home at 2600 Peachtree Road in Buckhead designed by Pringle and Smith. (Both courtesy of Beaumont Allen.)

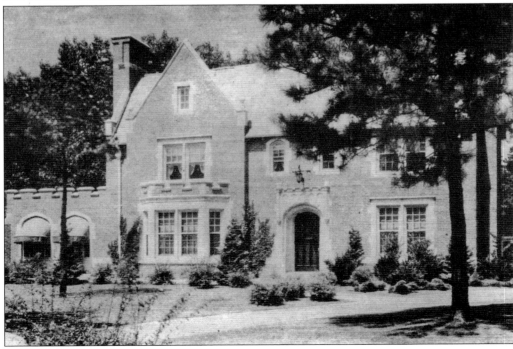

Ivan E. Allen Jr. (1911–2003) went into his father's business after graduating from Georgia Tech. In 1936, he married Louise Richardson (1917–2008), the daughter of Hugh T. and Josephine (Inman) Richardson, and they had three sons. After serving in the army during World War II, Allen became Gov. Ellis Arnall's executive secretary. In 1946, he became president of Ivan Allen Company. Allen served two terms as mayor of Atlanta from 1962 until 1970. Louise Richardson attended Vassar College and also made her mark in the community. She cofounded the Atlanta Speech School, was a founding member of the Westminster Schools board, and was chair emeritus for life of the Atlanta Historical Society. She was the driving force behind the Atlanta Historical Society's purchase of the Swan House property. In 1969, the City of Atlanta honored her as "Woman of the Year." (Courtesy of Beaumont Allen.)

In 1920, J. Epps Brown, board chair of Southern Bell Telephone and Telegraph Company, built this English manor–style house on the corner of Peachtree and West Wesley Roads. After Brown's death in 1925, Judge Shepard Bryan and his wife, Florence (Cobb), bought the house. Judge Bryan was a senior partner in the firm of Bryan and Middlebrooks. Florence Bryan was a granddaughter of Confederate general T. R. Cobb. (Courtesy of Shepard B. Ansley.)

There were several apartment houses built along Peachtree Road in Buckhead in the 1920s. Pictured above is the red brick Canton Apartments at number 2804, across the street from Rumson Road. It was renovated in 1983 by Renaissance Investment, Inc., and converted into 46 condominium units. It was then renamed the Crestwood. (Courtesy of author.)

Eight

BUCKHEADIANS GO TO THE MOVIES, SCHOOL, AND CHURCH
1930s

During the late 1920s, when Buckhead's population was 2,603, high school students went to Fulton High School in downtown Atlanta. Parents Mrs. Morton Rolleston, Mrs. Alfred D. Kennedy, and Philip C. McDuffie spearheaded a movement to establish a high school in the Buckhead community. Ten acres of land in Garden Hills were purchased, and renowned architect Philip Trammell Shutze designed the schoolhouse; North Fulton High School opened in 1930. (Courtesy of author.)

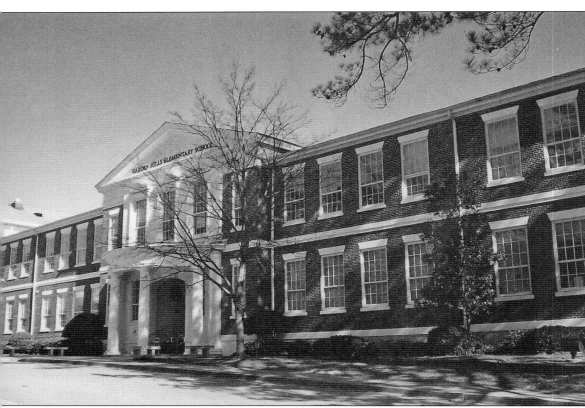

In 1938, Fulton County commissioned the construction of an elementary school on Sheridan Drive next to North Fulton High School. The architectural firm of Tucker and Howell designed the building, and the school was constructed by the Works Project Administration (WPA). Garden Hills Elementary School opened in September 1939. (Courtesy of author.)

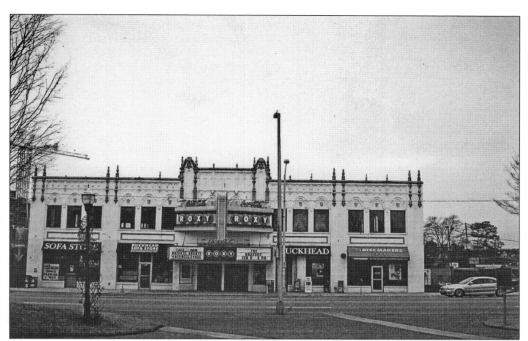

Mrs. Montine Donald Chestnut and Mrs. Lottie D. Trawick built the Buckhead Theater (above) on Roswell Road in the center of the village in 1927 for $120,000. Architects Danielle and Beutelle designed the Spanish Baroque–style building, which opened in 1930. White patrons bought their tickets at the main ticket office and entered the theater from the front. Black patrons came in from Irby Alley (Irby Avenue), bought their tickets, and climbed a flight of steps at the rear of the building to sit in the balcony. In 1950, John and Ruth Carter purchased the theater and changed the name to the Capri. That same year, they built the Fine Arts Cinema (below), which was later renamed the Garden Hills Theater, on Peachtree Road at Rumson Road. Today the Buckhead Theater is called the Roxy, and the Garden Hills Theater is closed. (Above courtesy of author; below courtesy of Ruth Carter.)

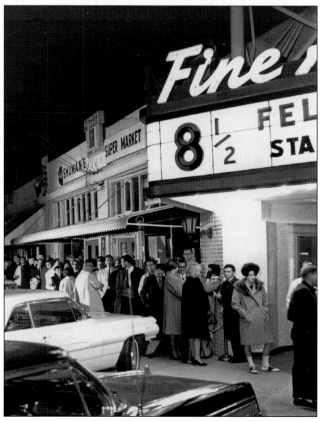

In 1929, Ponce de Leon Baptist Church bought a lot on the corner of Peachtree and East Wesley Roads. On August 3, 1930, the church held its first service in the partially constructed sanctuary. The following month, it merged with Buckhead Baptist Church. In 1932, it merged with Second Baptist Church, and the new church became Second Ponce de Leon Baptist. The Georgian-style building was completed in 1937. (Courtesy of Second Ponce de Leon Baptist Church.)

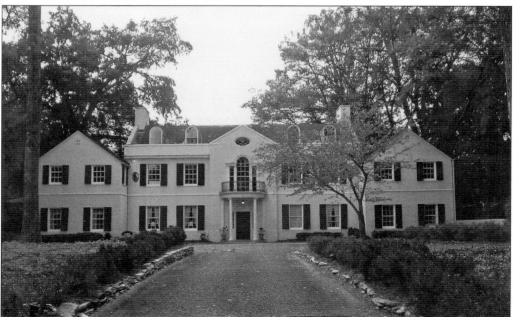

Architect Philip Trammel Shutze and Mrs. James J. Goodrum designed this Regency-style house on West Paces Ferry Road in 1931. Mrs. W. W. Rushton bought the home in 1957 and named it the Peacock House in honor of the birds she raised. In 1984, Peter and Julia White purchased the house for the Southern Center for International Studies. (Courtesy of author.)

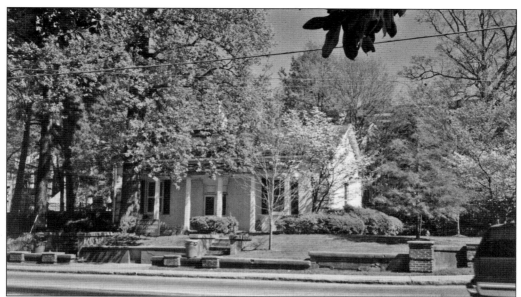

Left with three small children to raise after her husband, Herbert, died in 1905 of the hiccups, Mary Harwick Bloodworth opened a small kindergarten in Druid Hills for her friends' children. Around 1930, she rented the building that Eretus "E" Rivers had used for his office during the development of the Peachtree Heights neighborhood and relocated her school in Buckhead. It was first called E. Rivers Kindergarten, but soon it became known as Mrs. Bloodworth's Kindergarten. Mary Bloodworth taught the small charges with the assistance of her daughter, Mary Hill Bloodworth Woodruff. The class picture taken in 1931 shows Mary Bloodworth and her students. In the background, across the street, is E. Rivers Elementary School. (Above courtesy of author; below courtesy of Bruce Woodruff Jr.)

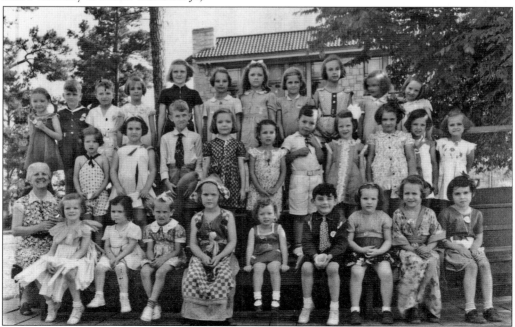

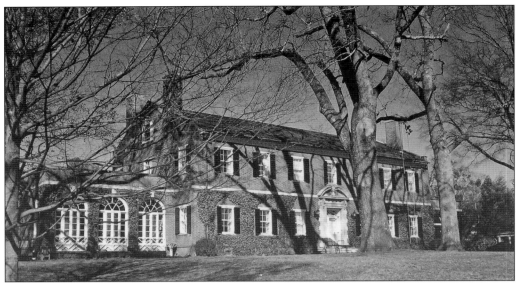

In 1924, Robert Maddox fashioned a road through his property and named it Woodhaven Road. On the northeast corner of West Paces Ferry and Woodhaven Roads, he sold 50 acres of land to Mr. and Mrs. William H. Kiser. At first, they built a brown-shingled summer cottage in 1931. This was replaced by a Georgian mansion designed by Philip T. Shutze that they called Knollwood. It was modeled after Chatham, an 18th-century pre–Revolutionary War mansion in Stratford County, Virginia. In 1952, the home was sold to Dr. and Mrs. Bernard Wolff, who sold off lots. The photograph below shows the Kisers with their three sons, standing in back from left to right, Marion, Dr. William Jr. (a pediatrician), and Lawson, and their wives, and their children. (Above courtesy of author; below courtesy of Edyth Kiser Shadburn.)

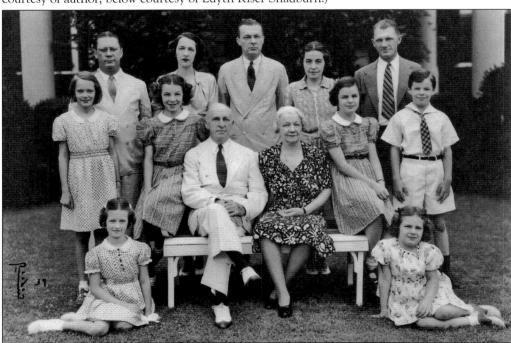

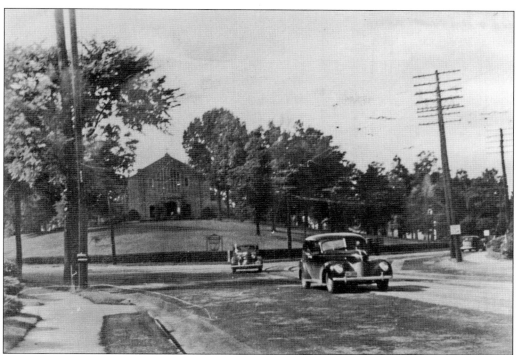

The Cathedral of St. Philip moved to Buckhead from downtown Atlanta in 1933 to accommodate its parishioners. The church leased land at the point of Peachtree Road and Andrews Drive and built the Pro-Cathedral. They later bought the property and built the Hall of Bishops. The original church building was torn down and replaced by a Gothic-style cathedral that celebrated its first service on Easter Sunday in 1962. (Courtesy of Alva and Mildred Lines.)

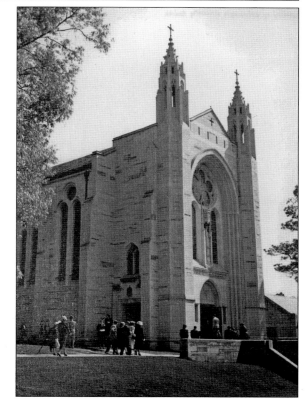

In 1938, the Diocese of Savannah-Atlanta bought the Ku Klux Klan property on the east side of Peachtree Road between East Wesley Road and Peachtree Way. Henry Dagit and Sons of Philadelphia designed the 13th/14th-century Gothic–style cathedral. During construction, church services were held in the former Ku Klux Klan Imperial Palace. The Cathedral of Christ the King was dedicated on January 18, 1939. (Courtesy of Elizabeth Haverty Smith.)

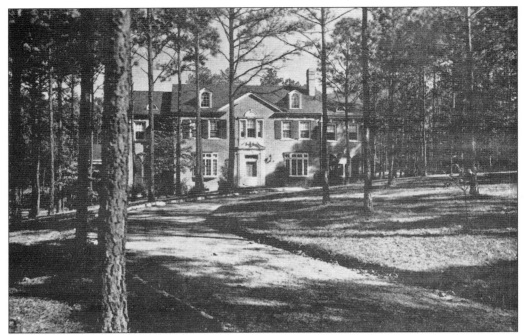

Following James Dickey's death in 1911, a total of 300 acres of his land on West Paces Ferry Road was sold to Charles Harman Black's Tuxedo Park Company for $75,000. The land was subdivided into large tracts (Paces Ferry, Tuxedo, Valley, and Habersham Roads and Northside and Blackland Drives) and sold at auction from $2,000 to $2,500 per lot. Above is the home of world-famous golfer Robert "Bobby" Tyre Jones Jr. (Courtesy of Dodie Black Stockton.)

The Hugh P. Nunnally family built one of the most famous homes in Buckhead in Tuxedo Park in 1936–1937. The Georgian-style home at 281 Blackland Road played host to Clark Gable and Carole Lombard during the premiere of *Gone with the Wind*. His Royal Highness Prince Faisel M. Saud Al Kabir of Saudi Arabia bought the house in 1978. It went into foreclosure in 1987 and was sold at auction. (Courtesy of Dodie Black Stockton.)

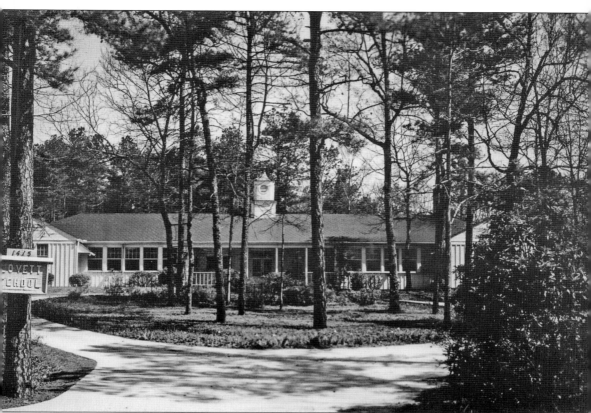

Eva Edwards (Mrs. William C.) Lovett opened the Lovett School in downtown Atlanta in 1926, and by November 1936, the school was located in Buckhead on West Wesley Road. Eva Lovett retired in 1954, and the school's ownership went to the Cathedral of St. Philip. When it outgrew its facilities, a new school was built on Paces Ferry Road at the Chattahoochee River and opened in September 1960. (Courtesy of the Lovett School.)

Edward Leverette Springer, the father of twins Robert and Edward, opened a grocery store on Howell Mill Road in 1900 that was in business for 66 years. He also had a farm and a sorghum mill at the site of the present Ahavath Achim Synagogue. In 1937, Robert and Edward opened Springer Brothers Market on Peachtree Road at Peachtree Creek. Later they moved north a block to the site of the present Talbot's at the Peachtree Battle Shopping Center. They retired in 1971. (Courtesy of Jean Springer Travis.)

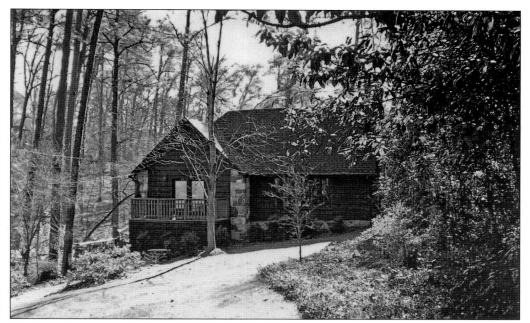

Not all homes in Buckhead during this period were palatial or on multiple acres of land. One example is this log house on West Wesley Road between Northside Drive and Habersham Road that was built in the 1930s by Fanny Manley. When she moved to a home on Rilman Road, Dr. and Mrs. William Mitchell bought the property. (Courtesy of the author.)

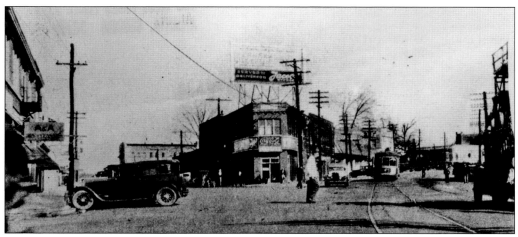

This photograph is a wonderful vintage picture of the heart of what is called the Buckhead Village. Taken in 1934, it shows what changes had transpired since 1910. Jacob's Drugstore sits where George Brumbelow had his blacksmith shop. Roswell Road (left) and Peachtree Road (right) have been paved, and the Buckhead trolley is heading south toward downtown Atlanta. (Courtesy of the Atlanta History Center.)

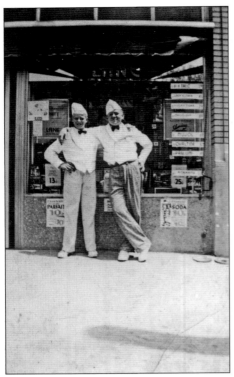

During the 1930s, J. L. Hawk, Wender and Roberts, Lane Drug Company, Schley's, and Jacob's Pharmacy operated on Peachtree Road within a few blocks of each other in the Buckhead Village. Thomas C. Cox Drug Store was there in 1940, and Hitchcock and Simmons Drug Store was open by 1950. This photograph shows Charles Wilson and Billy Bowen in their soda jerk attire in front of Lane Drug Company in 1937. (Courtesy of Charlie Wilson.)

About 1900, Dr. Robert Lawson Hope sold 1,000 acres around today's Chastain Park to Tony Chastain. Toward the end of the Depression, the WPA and Fulton County prisoners built a 6,000-seat amphitheater. After Buckhead was annexed to Atlanta, the city sponsored free concerts there. In the summer of 1953, the Municipal Theater under the Stars began outdoor concerts. (Courtesy of the Atlanta History Center.)

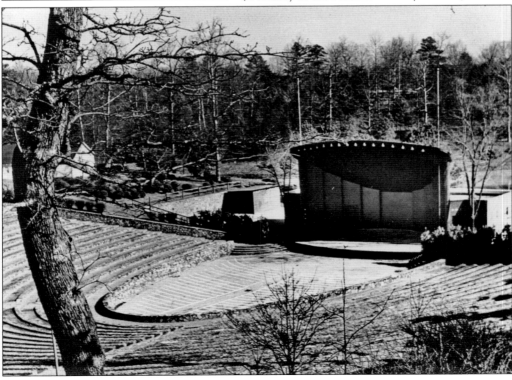

In the late 1800s, Julius Alexander bought over 100 acres in Buckhead on Peachtree Road at Wieuca Road. When he died in 1917, his son Harry inherited the property. In the mid-1930s, architect Lodowick J. Hill Jr. designed a Southern Colonial–style home for Harry, Marion, and their four children. Harry Alexander offered the home, called Peniel, to the state in the 1940s for the governor's mansion but was rejected. A community activist, he was a founder of the Atlanta Historical Society, the Georgia Historical Commission, and the Atlanta Bureau of Jewish Education. He was a philanthropist and a Republican who served in the Georgia legislature. He was one of Leo Frank's defense attorneys. Alexander opposed annexing Buckhead into the city of Atlanta in 1952. Today Phipps Plaza sits on his land. Shown at right are the Alexanders and a grandchild. (Both courtesy of the Breman Museum.)

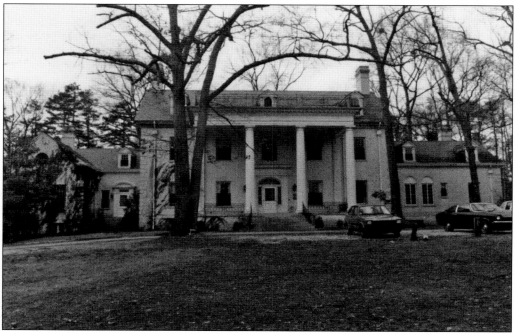

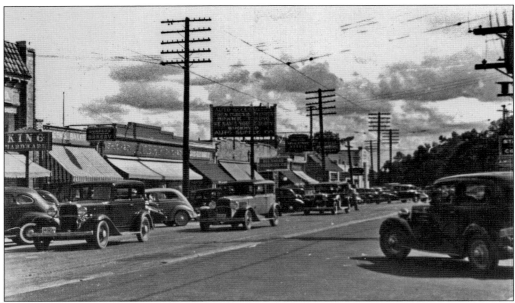

These pictures show what the Buckhead Village looked like in 1939. The photograph above shows businesses on the east side of Peachtree Road from near the corner of East Paces Ferry Road down to Buckhead Avenue. From left to right are King Hardware, Ray Durden's bakery, Emery's department store, Wood and Allen Market, and Buckhead Hardware. At the very end is Fulton National Bank. Note the vintage cars and the angled parking on Peachtree. The picture below shows Peachtree Road from West Paces Ferry north to the Sardis Way area. Note Jacob's Drugstore on the left. On the right side are Lane Drugs, Buckhead 5-10-and-25¢ store, H&W Sandwich Shop, the Whitehead liquor store, Buckhead Taxicab Company, Minhinnett's restaurant, and Langford's service station. (Courtesy of Alva and Mildred Lines.)

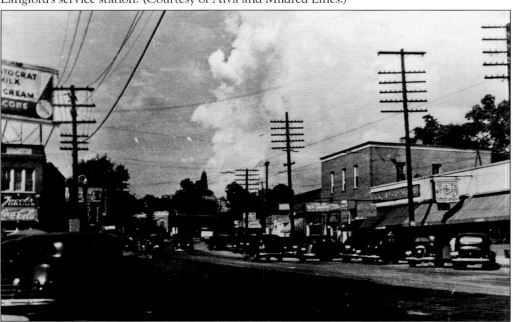

Nine

READING, RECREATING, AND WAR
1940s

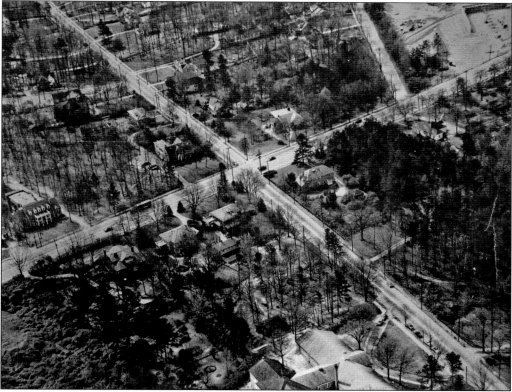

This aerial shot of the intersection of Peachtree and Piedmont Roads was taken in 1940. Peachtree Road runs from left (north) to right (south). On the southeast corner of Peachtree Road, between Maple Drive and Piedmont Road (top right), is the home of Eulah McKenzie. Across Piedmont Road on the northeast corner is Dr. Jerome Hugh Crossett's home. Next door to him is an apartment house. On the southwest side of Peachtree Road, across from Mrs. McKenzie, are the homes of Joseph L. Hammett and May G. Bailey. Fred J. Turner, Arthur C. Kitchens, and Darling P. McDaniel own the three houses on the northwest side of Peachtree Road north of Piedmont Road. The large building at the bottom of the photograph fronting Piedmont Road is R. L. Hope Elementary School. Note the lack of cars traveling in this area. (Courtesy of Alva and Mildred Lines.)

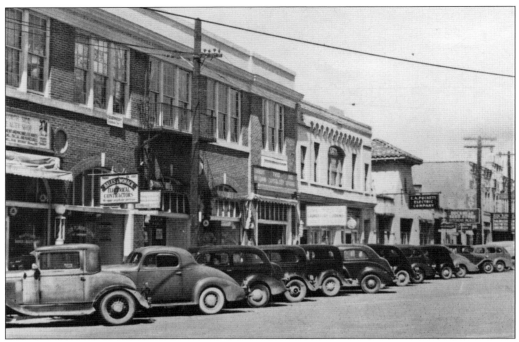

In this 1940 picture of Roswell Road at West Paces Ferry and Peachtree Roads, one can see the North Side Realty Shop, a barbershop with its barber pole, Bales and Womack Electrical Contractors, Trio Shoe Shop (for shoe repairs), electrical contractor C. A. Puckett, Buckhead Seed Store, and the Buckhead Theater. On the second floor are the Ida Williams Library, Rogers School of Dancing, and F. Robert Kennedy' real estate agency. (Courtesy of the Atlanta History Center.)

William Brand Sr. worked for Cottongim Seed downtown then moved to Buckhead in the late 1920s, when the company opened a Roswell Road store. Later he bought the store and renamed it the Roswell Seed Store. In the mid- to late 1930s, it also became Fulton County's police headquarters. During World War II, Brand and R. E. "Red" Dorough operated the Buckhead Draft Board from an office over the Buckhead Theater. (Courtesy of William Brand Jr.)

In 1917, Ida Williams, principal of R. L. Hope Elementary School, wanted a school library. After she retired, her Garden Hills woman's group collected books and money, and in 1929, they organized the Northside Library Association. The library opened, and Ida and her sister Emma operated it. Later, needing more space, it moved to the Sardis Masonic Lodge on the second floor in the McDuffie Building on Roswell Road, where it became the Ida Williams Library. The association wanted a stand-alone building, so money was raised and a lot was purchased on Buckhead Avenue. The architectural firm of Cooper and Cooper designed the neoclassical-style building, which was constructed by the WPA. It opened on January 8, 1942. In 1988, it was replaced by an ultramodern building designed by architect Mark Scogin of Scogin, Elam, and Bray. (Courtesy of Atlanta History Center.)

In 1943, Dr. Jerome Hugh and Mary Lee (Buchanan) Crossett bought this home, which had been built in the late 1920s by Luther C. McKenney. It sat on 7 acres on the northeast corner of Peachtree and Piedmont Roads. Dr. Crossett's hobby was growing roses in his garden, and during World War II, the family operated a victory garden. There was also a fishpond and a playhouse for their daughter, Fran, on the property. Dr. Crossett began his dental practice in Buckhead in 1923 with Dr. Lewis N. Huff. He opened an office in the early 1930s on Roswell Road next door to the Buckhead Theater, where he is shown above in his reception room. (Both courtesy of Fran Crossett Rosenthal.)

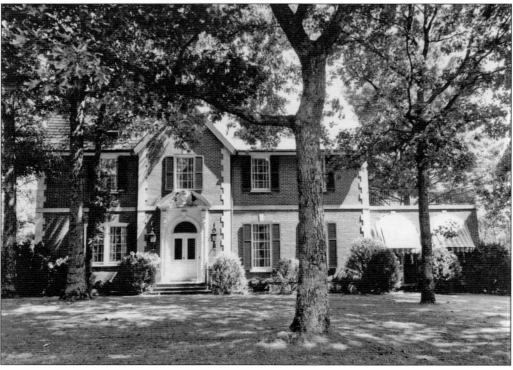

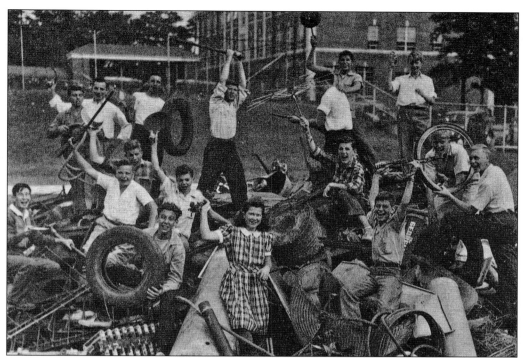

During World War II, schoolchildren become collectors of all sorts of items that they brought to their schools. They canvassed neighborhoods for newspapers, string, tin cans, toothpaste tubes, coat hangers, tires, tinfoil balls made from gum and cigarette wrappers, and other items to make products to help win the war. Shown here are North Fulton High School students with their pile of sundry items. (Courtesy of the Atlanta Public Schools.)

People in Buckhead did many things to aid the war effort during World War II. They hung blackout curtains in every window and bought food and gasoline with ration cards. Some families showed their Southern hospitality by opening their homes to entertain soldiers. One such person was Elizabeth Haverty, who is shown in 1943 entertaining soldiers from Lawson Hospital. (Courtesy of Elizabeth Haverty Smith.)

Scouting was an important program for the boys and girls in Buckhead. Boy Scout Troop No. 59 was organized in 1942 and met in the Boy Scout Hut on the grounds of the Peachtree Road Methodist Church. Two years later, Cub Scout Pack No. 3 was organized, and in 1948, the Explorer Scout Unit was formed. The first Girl Scout troop in the community was established at the church in 1944 and met in the hut, shown above. Later Mrs. Hugh Crossett and Mrs. Haygood Clark formed a Brownies group. This was followed by Intermediate and Senior Girl Scout troops. The picture of the Brownies Halloween party below was taken in 1945. Mrs. Crossett's daughter, Fran, is fourth from the right. (Above courtesy of Peachtree Road Methodist Church; below courtesy of Fran Crossett Rosenthal.)

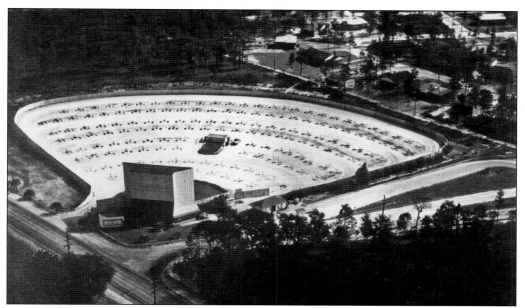

Drive-in theaters, an inexpensive form of entertainment for the automobile-driving public, were developed in the 1930s. In 1939, Harris Robinson and his partners bought several theaters in questionable areas in Atlanta. When they closed, the partners went to Savannah and built the first modern drive-in theater in the South. They returned to Atlanta in 1946 and built the Piedmont Drive-In at Lindbergh Drive and Piedmont Road. (Courtesy of Helen Robinson Peppiatt.)

Morris Brandon Elementary School was built in 1947 on West Wesley and Howell Mill Roads, once the site of Key's Dairy. The school's namesake donated the property. Brandon's parents moved to Atlanta after losing their Tennessee plantation during the Civil War. A graduate of Vanderbilt University and Yale Law School, he was active in the Democratic Party and served in the state legislature. He and his wife, Harriet (Inman), had three children. (Courtesy of author.)

Fritz Orr purchased land between Nancy Creek, West Paces Ferry, West Wesley, and Howell Mill Roads and opened a coed summer camp in 1938. The Fritz Orr Camp offered adventurous summers for energetic and athletic boys and girls. They participated in swimming, horseback riding, canoeing, tennis, crafts, archery, riflery, tumbling, wrestling, and nature. Campers also went on horseback trips to Kennessaw Mountain, climbed and slept on top of Stone Mountain, and canoed down the Chattahoochee River. The picture above at the Nature Hut shows Fritz Orr on the left and naturist Ross Allen on the right. The photograph below shows girls waiting for dinner before making the climb up Stone Mountain to spend the night under the stars. Today the Westminster Schools occupies part of the property. (Both courtesy of author.)

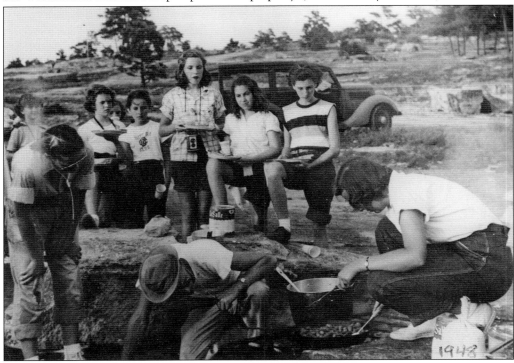

The Heyman Kessler family came to Atlanta from Macon, Georgia, during the Depression and opened H. Kessler and Company department store on Whitehall and Hunter Streets (now Peachtree and Martin Luther King Streets). Walter H. Kessler became chief executive officer of Kessler's, which he operated with his father and three brothers. Walter married Cecilia Tesler, and they lived with their daughters, the author and Nancy (Mrs. Thomas Tilchin), in an apartment on St. Charles Avenue. In 1949, the Kesslers built one of the first contemporary homes in Buckhead at 3370 Habersham Road between Knollwood and Valley Roads. Cecilia Kessler is responsible for getting the traffic light installed at the intersection of Habersham and West Paces Ferry Roads. From left to right are Susan Kessler Barnard (author), Walter Kessler, Nancy Kessler Tilchin, Tom Tilchin, and Cecilia Kessler. (Both courtesy of author.)

In the late 1930s, 1940s, and 1950s, many of the homes in Buckhead had outdoor badminton courts. In 1940, William T. Dreger Jr. built a two-story, indoor badminton court on the northeast corner of Piedmont Road and Lindbergh Drive that he rented out. The wooden building was later home to an antique furniture store. (Courtesy of author.)

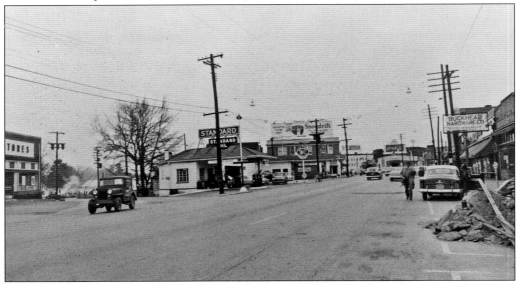

This is a 1948 shot of the Buckhead Village looking north on Peachtree Road from Buckhead Avenue. On the left is Colonial Store, which sat on Keith Circle. Charles K. Keith had owned a large piece of land. Around 1931, Fulton County condemned part of his property, cut a street through from Peachtree Road to West Paces Ferry Road, and named it Keith Circle. Years later, Peachtree Road was straightened. (Courtesy of the Atlanta History Center.)

Ten

POSTWAR BUILDING
EXPLOSION
1950s

The population in the Buckhead community exploded after World War II, as materials once used for the war became available for building new houses. This created a need for new schools. Northside High School was built on Northside Drive between West Wesley and Arden Roads, and opened in the spring of 1949 for students who lived on the west side of Peachtree Road. Only grades 8 to 11 attended that first year; the senior class remained at North Fulton. This is a picture of Northside High taken the following year. (Courtesy of the Atlanta Public Schools.)

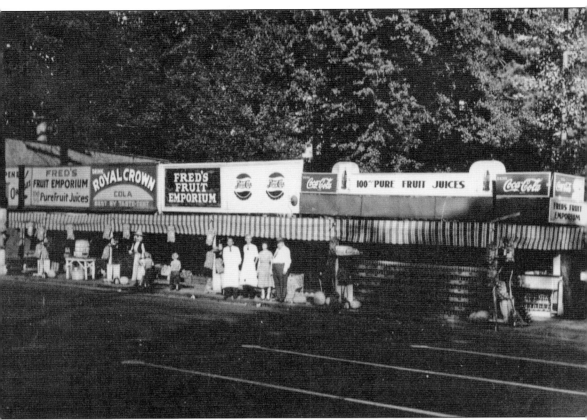

Fred's Fruit Emporium was a popular spot, particularly in the summertime, for Buckheadians and people from other Atlanta neighborhoods. Located on Peachtree Road in front of the present Peachtree Battle Shopping Center, it was owned and operated from 1940 until 1963 by Fred J. Golden. In the summer, customers bought slices of cold watermelon, placed them on metal Coca-Cola trays, then went out back and sat at tables on the deck. There they ate the sweet, juicy fruit, and many customers spat the melon seeds over the railing into the woods. (Courtesy of the Peachtree Battle Barber Shop.)

Atlanta's mayor, William B. Hartsfield, was concerned that so many residents were moving north of the city into unincorporated Fulton County. He tried several times but failed to incorporate Buckhead into the city. In 1949, the Georgia legislature established the Government Commission of Fulton County, and Joseph Heyman and Philip Hammer were hired to write a Plan of Improvement for annexation. The plan was voted on, approved, and went into effect on January 1, 1952. It tripled the size of Atlanta. Mayor Hartsfield is pictured to the right. The picture below shows some of the people against annexation burning the mayor and both of the Atlanta newspapers in effigy. Henry Alexander is on the left of the caskets with his hat in hand, and E. R. "Red" Dorough is at the right with a doll in his arms. (Above courtesy of the Atlanta History Center; below courtesy of the Breman Museum.)

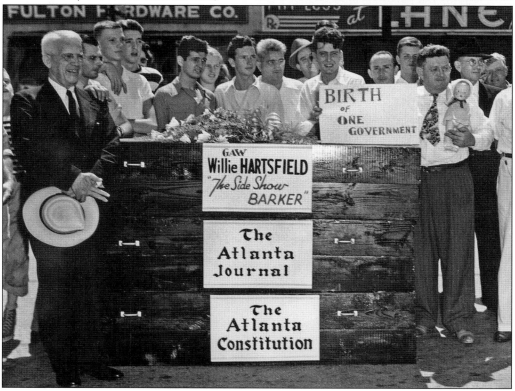

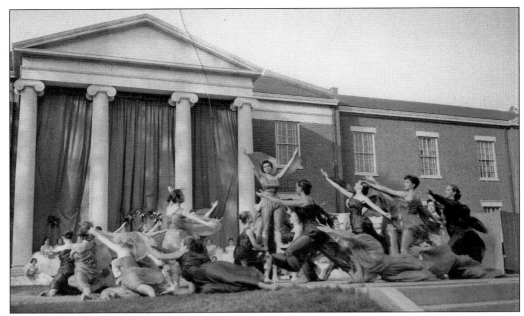

In 1951, the Board of the North Avenue Presbyterian School opened a new, coeducational Christian school that they named the Westminster Schools. The school moved in 1953 onto land next to Fritz Orr Camp that the board acquired from school trustee Fritz Orr. That same year, Washington Seminary girls' school closed, and it merged some of its faculty and students with Westminster. Under Dr. William L. Pressley's supervision, Westminster quickly adopted the College Board's Advanced Placement program. The photograph above shows a May Day pageant in 1955 on the steps of Askew Hall, the girls' school. The picture below is of the boys' school building, Campbell Hall. (Both courtesy of the Westminster Schools.)

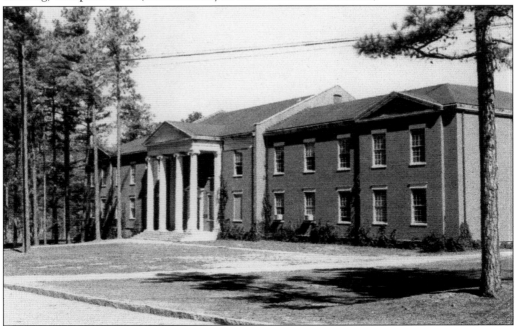

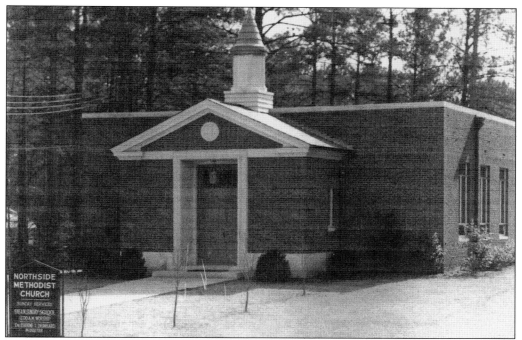

Northside United Methodist Church was organized in 1950 with 154 charter members. In 1952, they built Gilbert Hall under the leadership of pastor Dr. Eugene Drinkard. This building, on Northside Drive, served as the sanctuary and the fellowship hall. Sunday school classes were held next door at Northside High School. A two-story educational building opened in 1955, and two years later, the main church sanctuary opened. The church operated an excellent nursery and kindergarten program that was open to the children in the community. The photograph below shows Dr. Drinkard along with some of his congregation celebrating the church's first birthday in front of Gilbert Hall. (Both courtesy of Northside Methodist Church.)

Every spring, many a young boys' and girls' fancy turned to leaving Atlanta and heading to the Florida beaches. Fort Lauderdale and Daytona were two of the most popular vacation spots. The jalopy above has a "Daytona or Bust" sign. From left to right are unidentified, Pepper Chastain, Ronnie Brown, Weyman Brown, unidentified, and Paul Kniekamp who are getting ready for their trip south. The picture below shows, from left to right, Judy Brantley (Weston), Fran Crossett (Rosenthal), and Virginia Nichols (Sanders) sitting on the back of Fran's convertible on the beach at Daytona. At this vacation spot, swimmers had to look both ways before getting in and out of the water, because cars continually drove up and down the beach. (Above courtesy of the Atlanta Public Schools; below courtesy of Fran Crossett Rosenthal.)

The first handbell team in the United States was composed of members of the Cathedral of St. Philip; their first performance was in 1952. In 1954, they performed at the White House during the lighting of the Christmas tree. While there, they met Pres. Dwight and Mamie Eisenhower and toured the White House. They also played in the Washington Cathedral. In 1955, they appeared on the *Ed Sullivan Show*. (Courtesy of Joan Torgesen Doyle.)

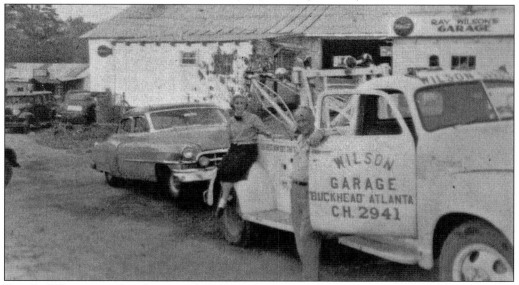

Ray C. Wilson owned and operated Wilson's Garage at 35 West Paces Ferry Road, right off of Peachtree Road. For many years, he repaired cars and towed those that could not make it to his shop. Today the Whole Food Market Shopping Center sits on his land. Shown here are Ray Wilson and Vicky Nettles. (Courtesy of the Atlanta Public Schools.)

Dr. Ludwig Amster opened the Amster Sanitarium on Capitol Avenue in 1904 to treat stomach and intestinal disorders. Later an operating charter for a surgical program was petitioned under the name Piedmont Sanitarium, and it became a full hospital in 1905; it became Piedmont Hospital in 1925. In 1943, the hospital bought Jack J. Spalding's Peachtree Road property, and Buckhead's first hospital opened in 1957. (Courtesy of Piedmont Hospital Archives.)

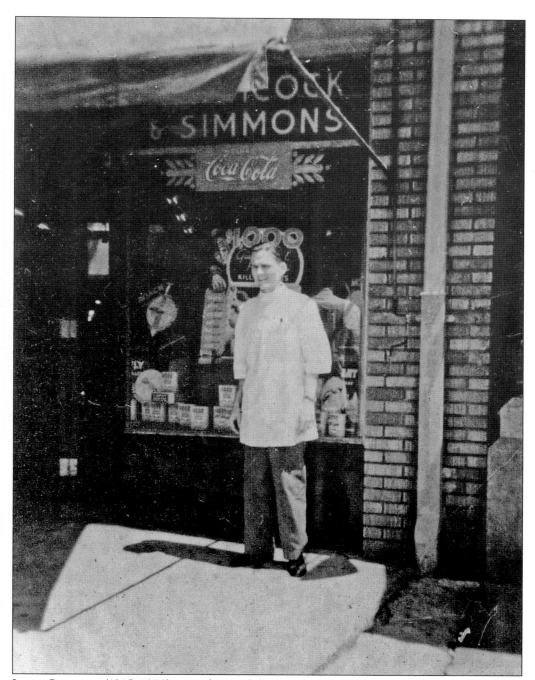

James Simmons (1915–1998), a graduate of the Southern College of Pharmacy, moved from Statesboro to Atlanta to work in his uncle's pharmacy. He married Betsy Shockley, and they had three children. In late 1930, he and Carol Hitchcock opened Hitchcock and Simmons Drugstore on Peachtree Road. The "doctors" became neighborhood physicians, and their drugstore dispensed medicine and milk shakes. It closed in 1973. "Doctor" Simmons is shown here in 1950. (Courtesy of Susan Simmons Johnson.)

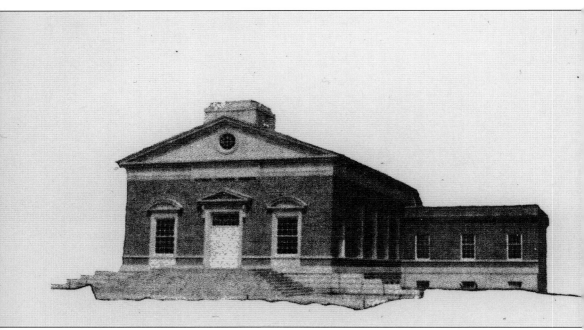

In 1951, a group of businessmen, professionals, and war veterans founded the Wildwood Baptist Chapel and celebrated their first worship service at Morris Brandon Elementary School in July. When it grew to 100 members, it became Northside Drive Church, later Northside Drive Baptist Church. Land on Northside Parkway at Northside Drive was bought in 1952, and ground breaking for the new sanctuary occurred in April 1954. In 1975, a Romanesque/Gothic sanctuary was dedicated. (Courtesy of Northside Drive Baptist Church.)

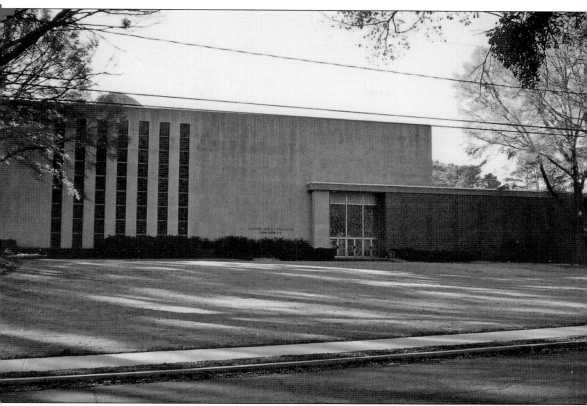

In 1887, Orthodox Jewish emigrants from Eastern Europe filed for a charter as Congregation Ahawas Achim, later Ahavath Achim. A synagogue was built on Piedmont Avenue and dedicated in 1901. When many in the congregation moved to the Buckhead area after World War II, land was purchased on Peachtree Battle Avenue at Northside Drive. A new synagogue was built, and Rabbi Harry H. Epstein conducted the first service in 1958. (Courtesy of author.)

In 1914, James W. Morrow bought 20 acres of land on West Paces Ferry Road and built a large home that burned down around 1929. John Ogden bought the property and built his castle in 1932; he died in the late 1940s. Pace Academy, an independent school organized in 1958 by an interfaith group, bought the property. The house was renovated into a school, and Frank Kaley served as the first headmaster. (Courtesy of Pace Academy.)

Edward E. Noble created one of the first shopping malls in America. The Ardmore, Oklahoma, native surveyed possible sites for his new shopping concept and chose Buckhead because it was a growing community. He purchased John K. Ottley's property and adjoining land totaling 72 acres on Peachtree Road in 1956. Fourteen months later, the $15-million Lenox Square mall opened for business on August 3, 1959. (Courtesy of the Atlanta History Center.)

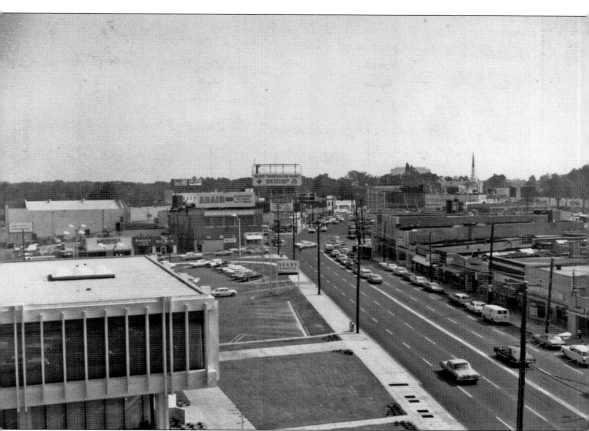

This 1960s picture of the Buckhead Village shows, on the right from Buckhead Avenue to East Paces Ferry, the Buckhead Men's Shop, Hitchcock and Simmons drugstore, and King Hardware. Not seen are Buckhead Hardware and Wender and Roberts drugstore. The steeple at the top right is Peachtree Road Methodist Church. On the left, on land once owned by Gov. John M. Slaton, are Peachtree Federal Savings and Loan Association and the Sear's parking lot. Across West Paces Ferry, on the corner under the Adair sign, is the McDuffie building. The white structure on the top left is the rear of the Buckhead Theater. In the center, under the Coca-Cola sign, is Jacob's Drugstore. Behind it are businesses including the Whitehouse Grill, the Thrift House, and Molly's Beauty Salon. (Courtesy of the Atlanta History Center.)

BIBLIOGRAPHY

Barnard, Susan Kessler. *Buckhead, A Place for All Time*. Marietta, GA: R. Bemis Publishing, Ltd., 1996.

————. "Children of the World, Nearly 50 Years Old Garden Hills Elementary Reflects Buckhead's Increasing Diversity and Sophistication." *Atlanta Buckhead*. June 1998: 10.

————. "Electric Avenues, Recalling Buckhead's Trolley Days." *Atlanta Buckhead*. June 2000: 8.

————. "From Movies to Music and More, Landmark Theater Still Hosts Variety of Entertainment." *Atlanta Buckhead*. July 1998: 18.

————. "Garden Hills' Shopping Strip." *Atlanta Buckhead*. April 1999: 9.

————. "High School History 101." *Atlanta Buckhead*. November September 2001: 23.

————. "Hope for the Needy, Dr. Robert Lawson Hope was an early crusader for Atlanta's Poor." *Atlanta Buckhead*. March 2000: 6.

————. "House of Style, Former Site of Stately Alexander Home is Now Atlanta's Most Elegant Mall." *Atlanta Buckhead*. May 2000: 12.

————. "Listening to Wisdom, Jack J. Spalding Was a Mover and Shaker in Atlanta." *Atlanta, Buckhead*. May 2001: 15.

————. "Multi-Faceted Legacy, Home of Early Buckhead Physician Late Became Site of Jewelry Empire." *Atlanta Buckhead*. October 1999: 8, 9.

————. "Peachtree Gardens Dance Hall." *Atlanta Buckhead*. November 2001: 10.

————. "Piedmont Hospital's Healthy History, What Started As a Private Practice Downtown Has Grown into One of Atlanta's Largest Hospitals." *Atlanta Buckhead*. July 1999: 8.

————. "A Proper Library, There May Be New Designs, but Property in Buckhead Will Always Be a Library." *Atlanta Buckhead*. November 2000: 12.

————. "The Poor House's Rich Legacy." *Atlanta Buckhead*. September 1999: 8.

————. "The Rise and Fall of Bagley Park." *Atlanta Buckhead*. August 2000: 12.

————. "Shepard Bryan Home, Two West Wesley." *Atlanta, Buckhead*. August 2000: 10.

————. "Under and Among the Stars, Chastain Park Has a Long History." *Atlanta Buckhead*. September 2000: 9.

Bell, Bill. "The Life of Nancy Plaster." *Historical News*. March/April 1994.

Boutwell, Anne Taylor. "Remembering the Calhouns, One of Buckhead's First Families Was a Driving Force behind Medicine Arts." *Atlanta Buckhead*. November 2003: 1, 11.

Britt, D. L. "A Steeple of History—Paces Ferry United Methodist Church."

Brown, Drew. "If These Walls Could Talk, A Classic Buckhead Mansion has Housed Generations of Socialites." *Atlanta Peach Magazine*. April 2008: 78.

Buckhead in Bloom. The Atlanta Preservation Center, March 2008.

Candler, Ex-Governor Allen D., and Evans, Gen. Clement A., eds. *Georgia: Comprising Sketches of Counties, Towns, Events, Institutions and Persons Arranged in Cyclopedic Form*, Vol. 1. Atlanta, GA: State Historical Association, 1906: 218, 219.

Collier, Dwight A., and Moore, Martha Dingler. *The Chinaberry Tree Visited*. Baltimore, MD: Collier and Moore, 1992.

Corbin, Jeff. "Landmark House Relocated on Site of 2500 Peachtree." *The Northside/Sandy Springs Neighbor*. December 2, 1988.

Ecelroy, Tina. "Nunnally House, an Old Arab Family Finds Common Ground with South." *Atlanta Journal* and the *Atlanta Constitution*. January 21, 1978: 4B.

"Garden Hills." *Atlanta Journal* and *Atlanta Constitution*, Homefinders section. July 5, 1992.

Goldstein, Doris H. *From Generation to Generation, A Centennial History of Congregation Ahavath Achim 1887–1987*. Atlanta, GA: Capricorn Corporation, 1987.

"Gracious Living in the Heart of Buckhead, the Gately–Loridans Estate." *The Decorators' Show House*, Vol. 23 (1993): 7, 8, 10.

Haverty, Rawson. *Ain't the Roses Sweet, 137 Years in Atlanta*. Rawson Haverty Sr.: Atlanta, 1989.

The House in Good Taste, Swan House, 1928. Atlanta Historical Society, 1980.

Jones, Paul. "Modern Drive-In Theaters Are Now Haven for Families." The *Atlanta Journal* and *Atlanta Constitution*. June 22, 1952: C1.

Mitchell, William R. Jr., and Martin, Van Jones. *Classic Atlanta, Landmarks of the Atlanta Spirit*. New Orleans, LA: Martin St. Martin, 1991.

Pendergrast, Nan. "The Way It Was: Pleasant Hill." *Paces News*: 5.

Salter, Sallye. "28 Buckhead Condo Units to Be Put Up for Auction." *Atlanta Constitution*. March 29, 1991: 3.

Schroder, Van Spalding. Letter, May 1, 2003.

Schwartzman, Grace M. and Barnard, Susan K. "A Trail of Broken Promises: Georgians and Muscogee/Creek Treaties." *The Georgia Historical Quarterly*, Vol. LXXV, No. 4. Savannah, GA: Georgia Historical Society, 1991: 697–718.

Simms, Peg. "Their 'Club' Remembers, Springer Bros. Market Closes." *The Neighbor*. February 10, 1971: 24.

Taylor, Ron. "Traces of Sadness, Too. Store Bids Adieu in Lively Style." *Atlanta Journal*. January 29, 1971: 6A.

Vickers, Dan. *Rolader Family History Descendents of William Joseph and Ann Gunter Rolader*. Atlanta, GA: Dan Vickers, 1998.

Westfall, Jill Elizabeth. "Crestwood Buckhead Building Was Once a Schoolhouse." *Atlanta Journal* and *Atlanta Constitution*, Homefinders section. February 11, 1996: 10.

The Westminister Schools, www.westminister.net. December 10, 2007.

Young, Dr. Neely. "A Brief History of Harmony Grove Cemetery."

www.arcadiapublishing.com

Discover books about the town where you grew up, the cities where your friends and families live, the town where your parents met, or even that retirement spot you've been dreaming about. Our Web site provides history lovers with exclusive deals, advanced notification about new titles, e-mail alerts of author events, and much more.

Arcadia Publishing, the leading local history publisher in the United States, is committed to making history accessible and meaningful through publishing books that celebrate and preserve the heritage of America's people and places. Consistent with our mission to preserve history on a local level, this book was printed in South Carolina on American-made paper and manufactured entirely in the United States.

This book carries the accredited Forest Stewardship Council (FSC) label and is printed on 100 percent FSC-certified paper. Products carrying the FSC label are independently certified to assure consumers that they come from forests that are managed to meet the social, economic, and ecological needs of present and future generations.

FSC
Mixed Sources
Product group from well-managed forests and other controlled sources

Cert no. SW-COC-001530
www.fsc.org
© 1996 Forest Stewardship Council

Find Your Place in History.